—

red
dresses
along
a
roadside

—

—

cool
burns

—

—

environmentally regressive policies

—

—
forgotten memories of the land
—

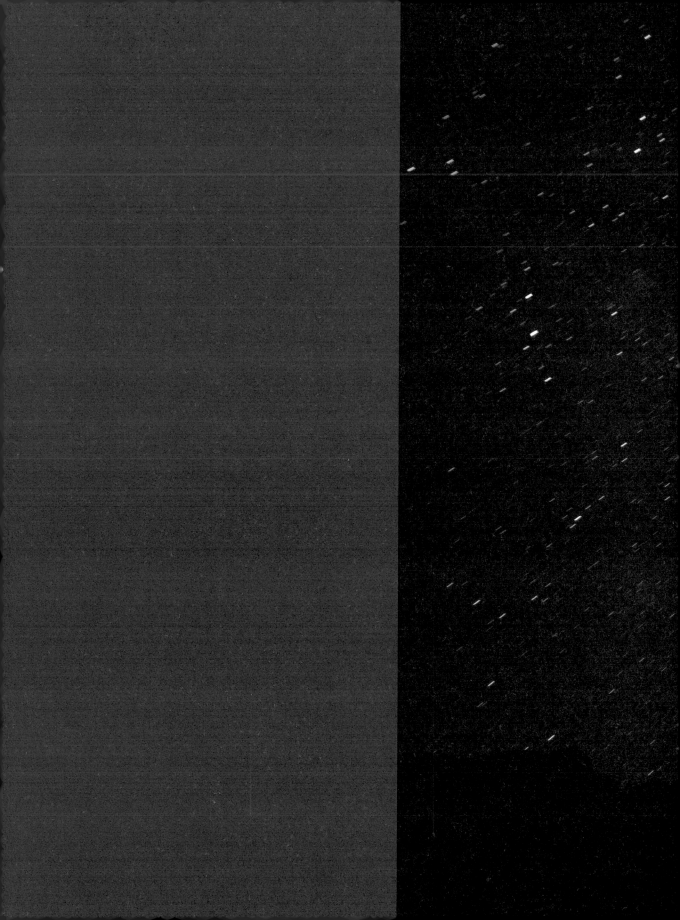

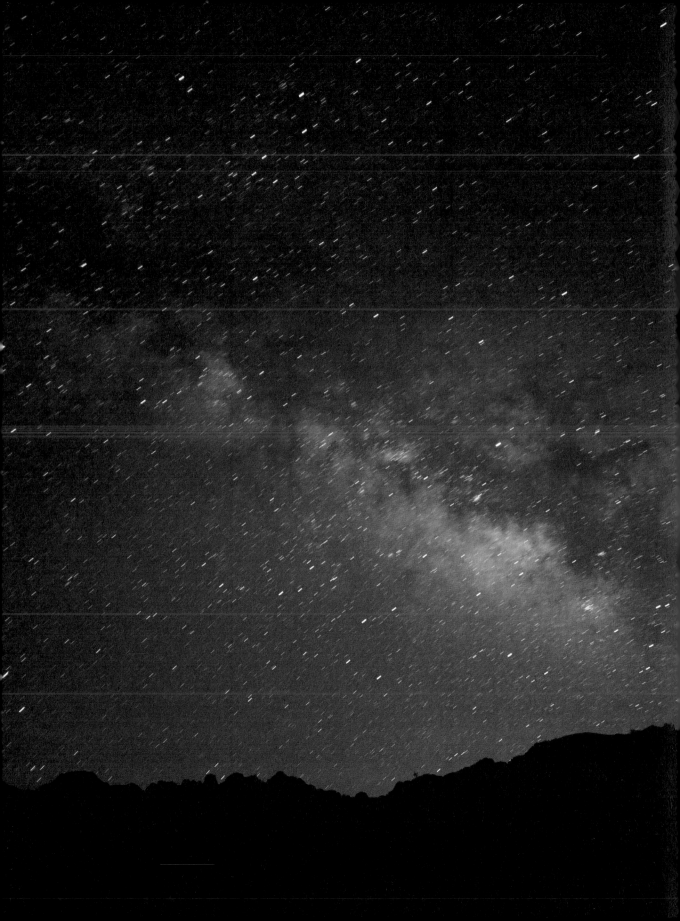

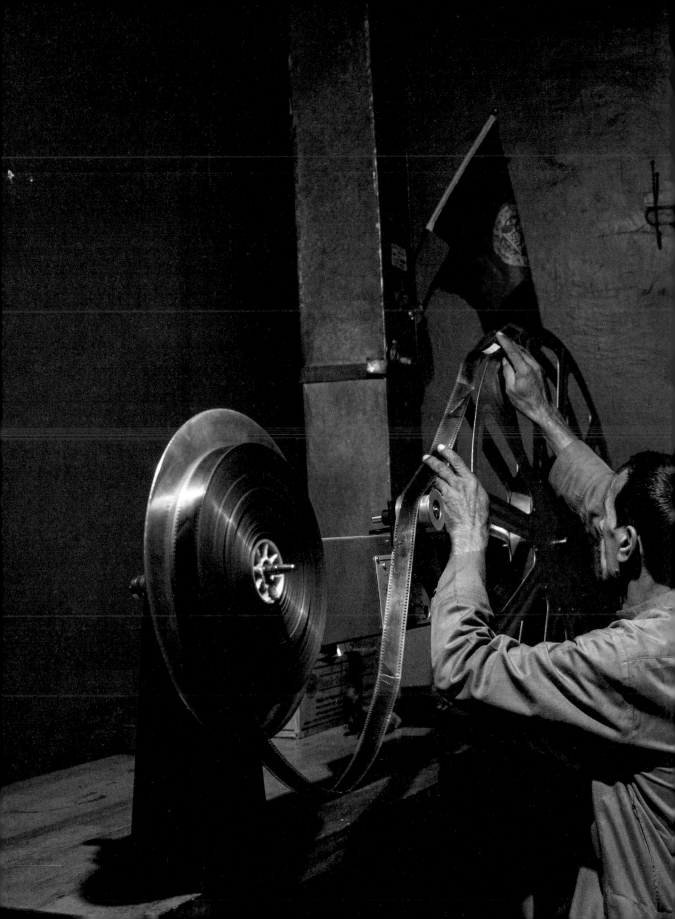

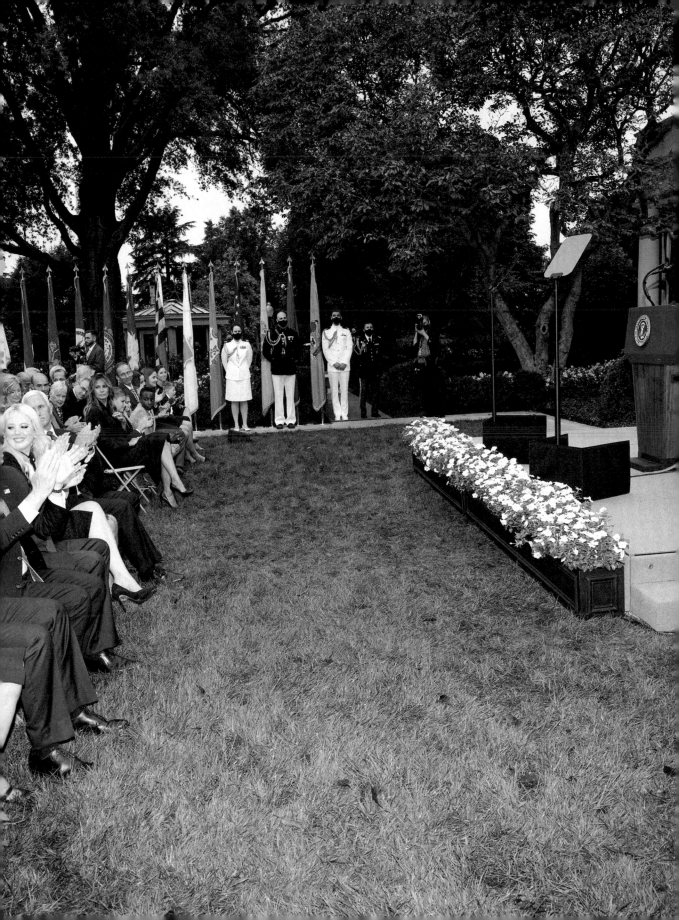

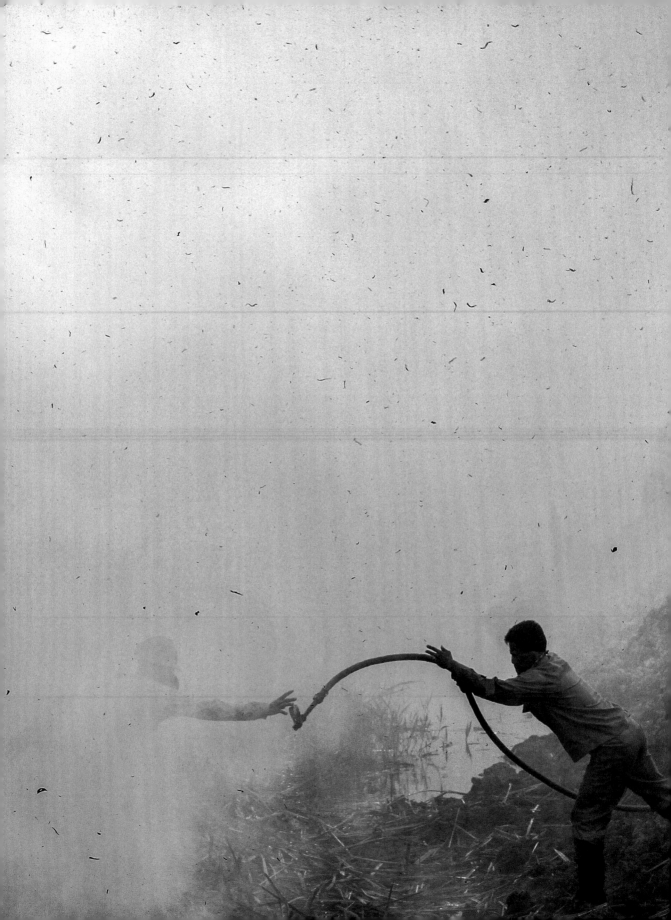

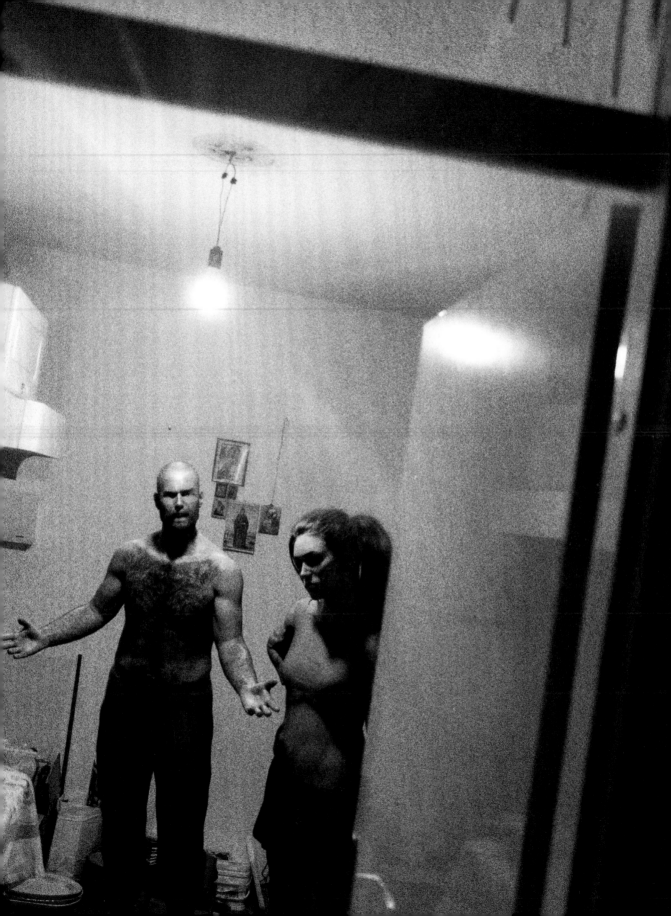

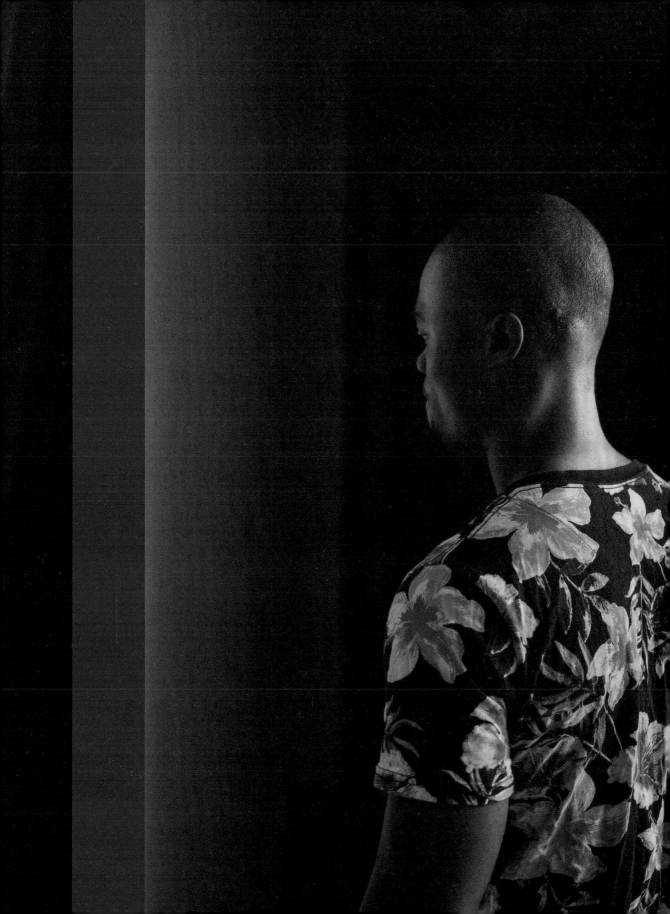

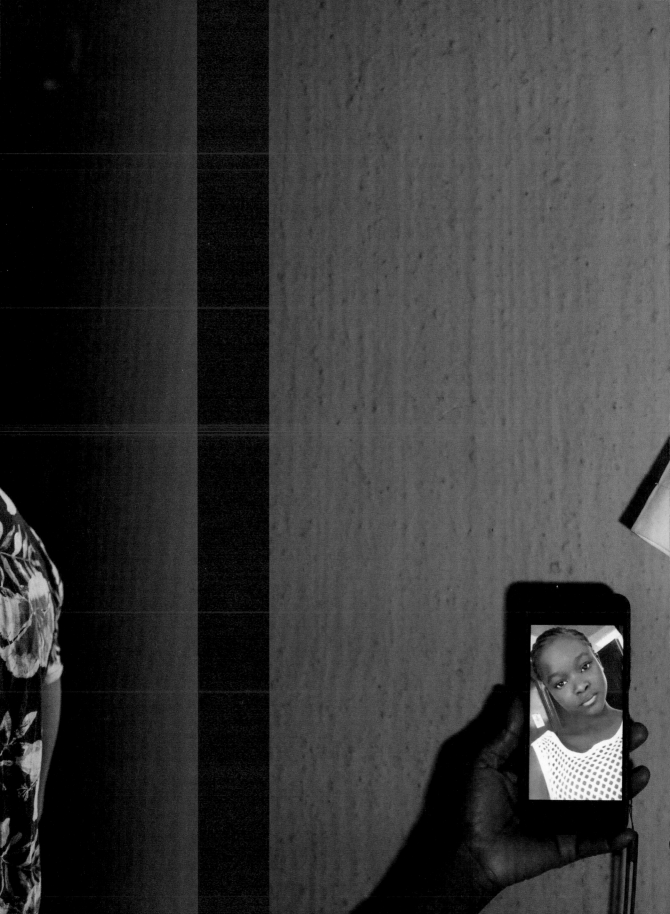

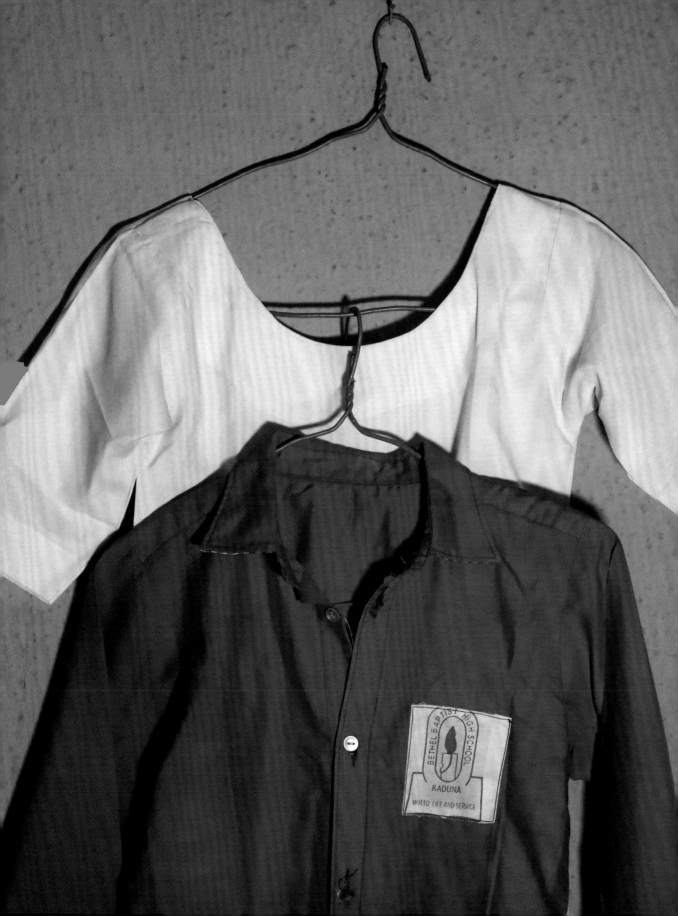

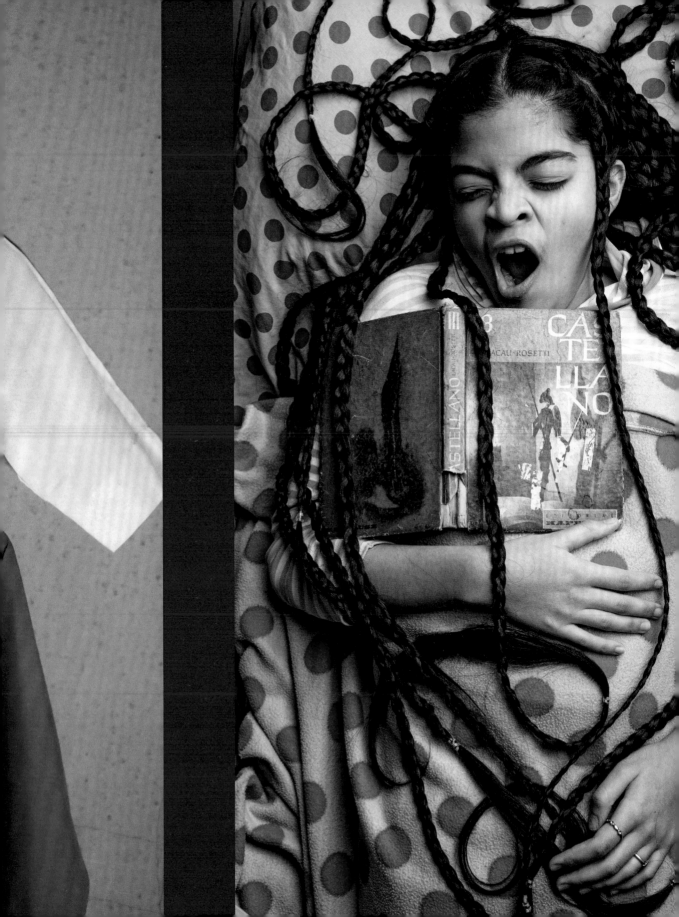

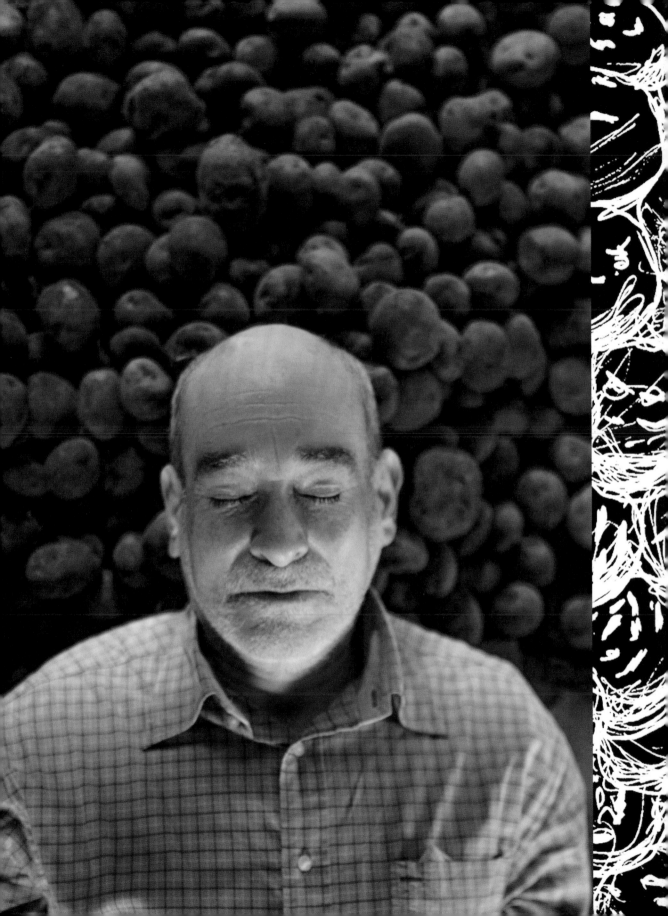

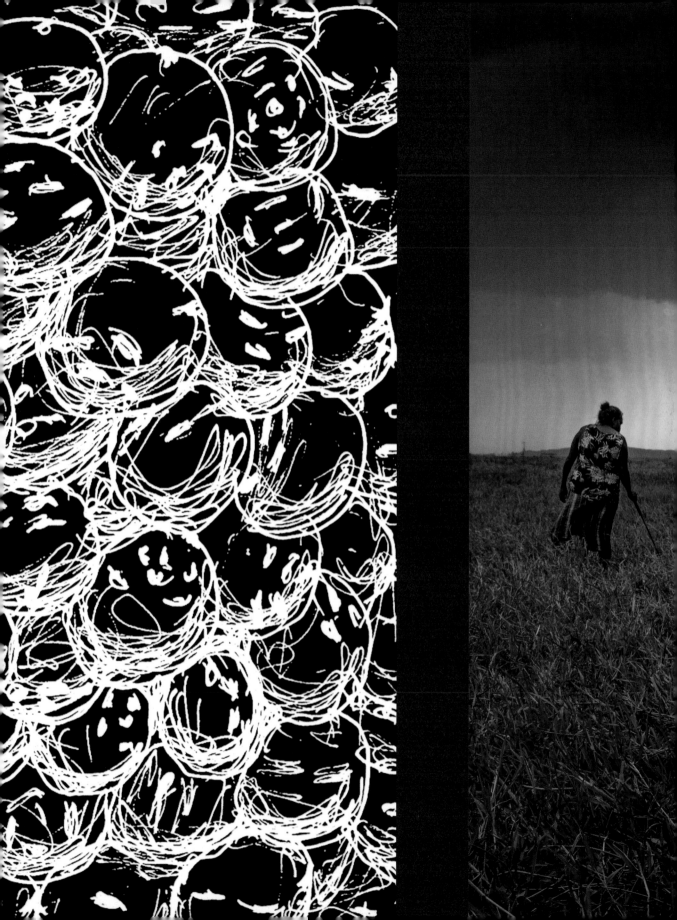

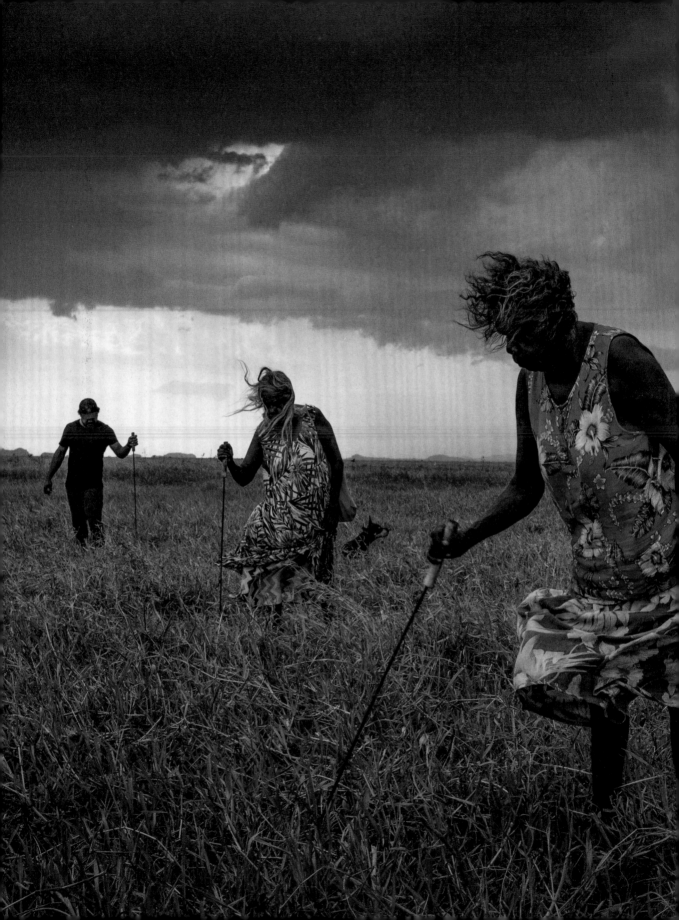

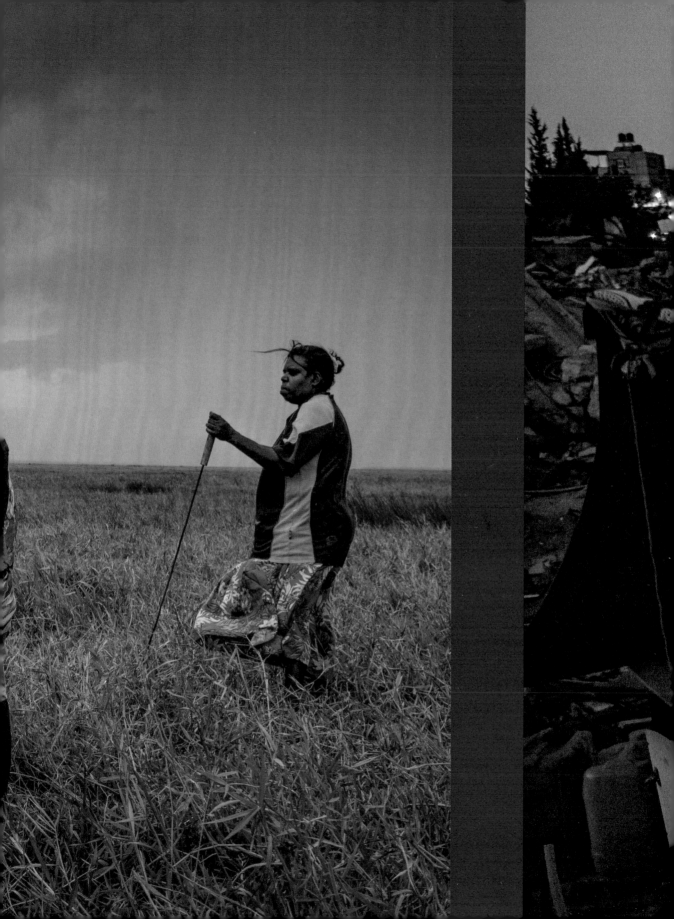

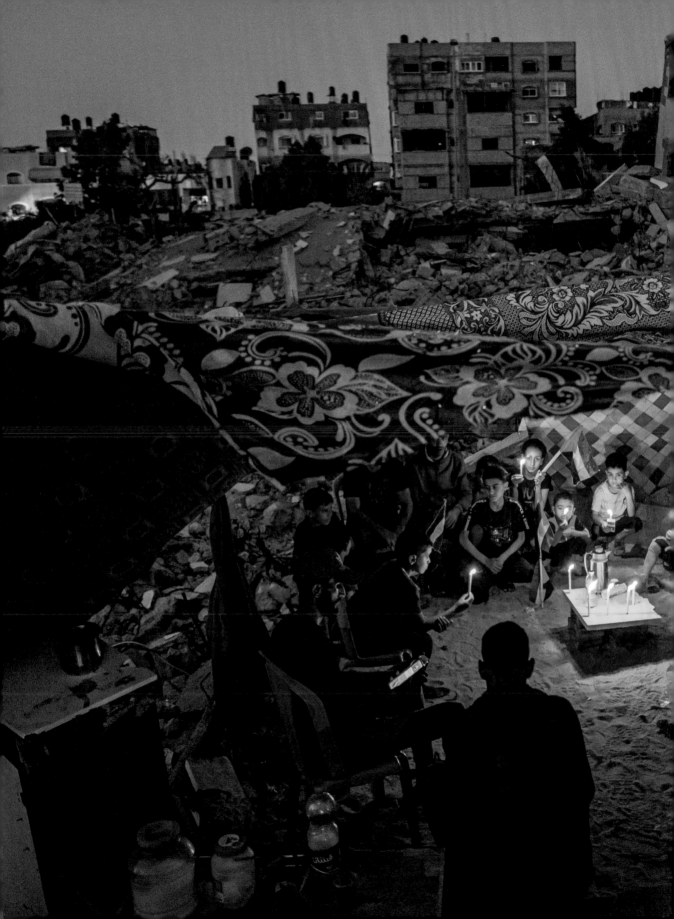

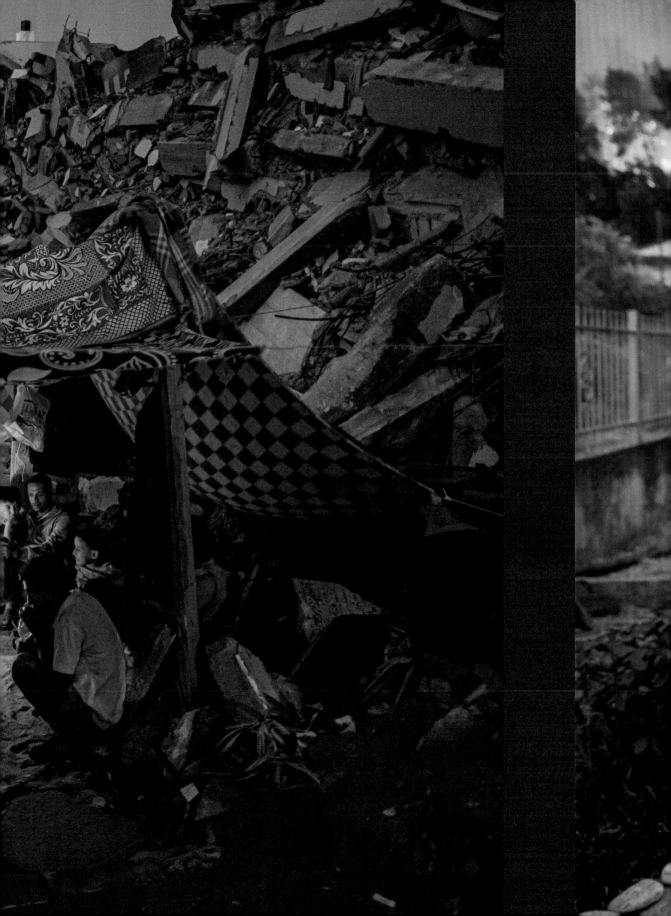

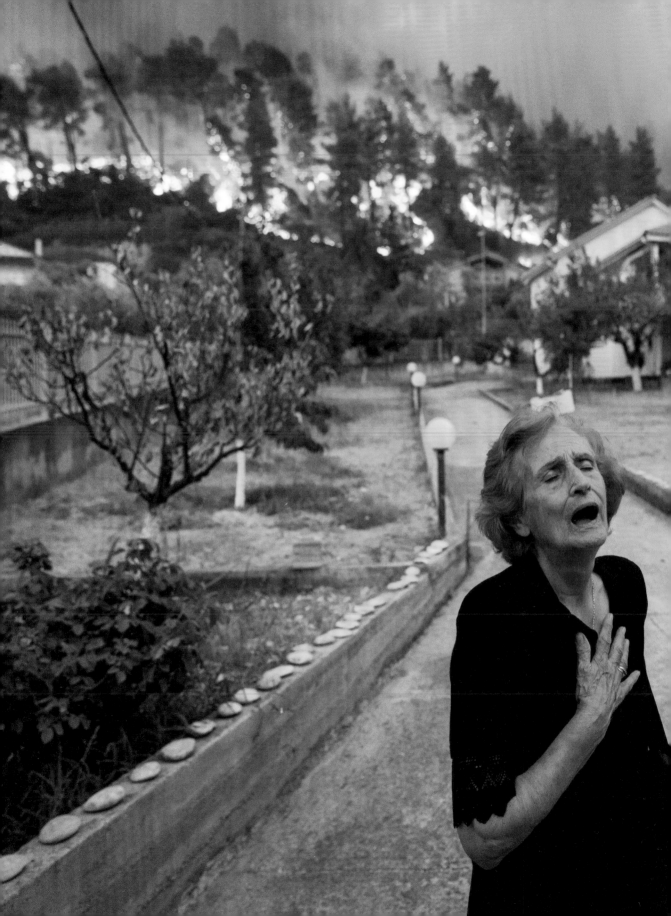

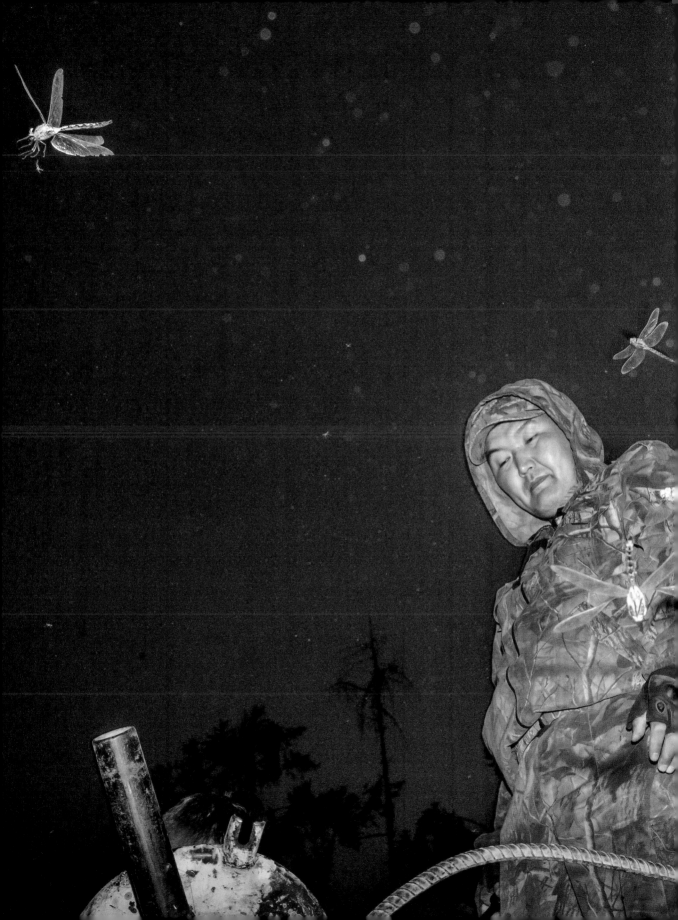

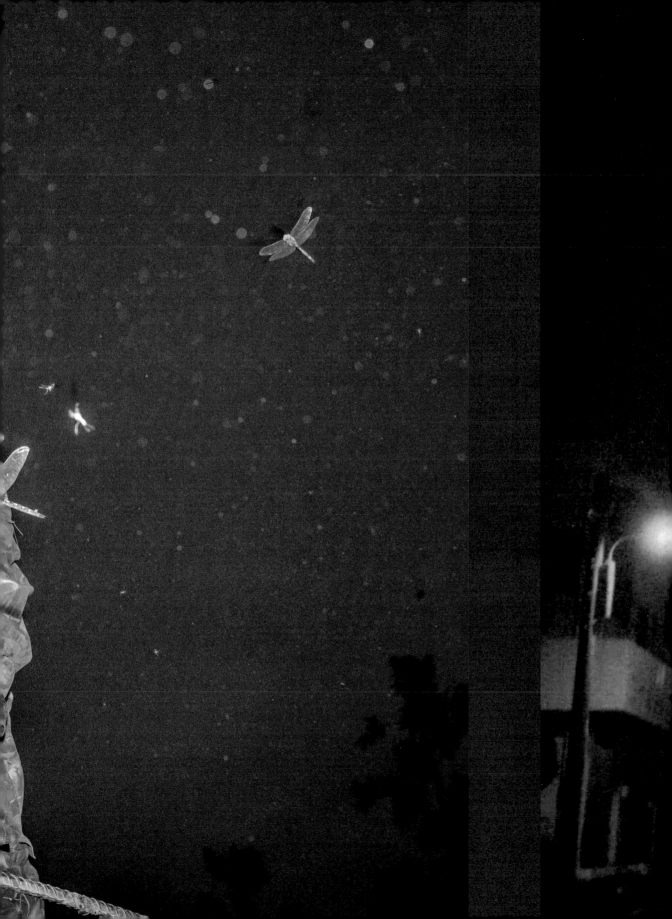

I have no idea how lo
this hotel has been he

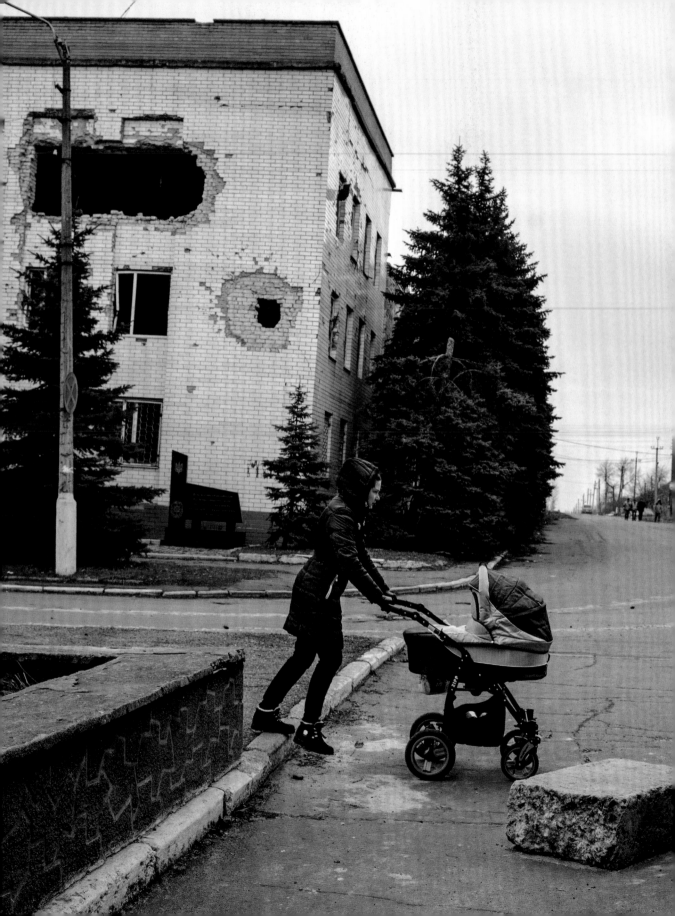

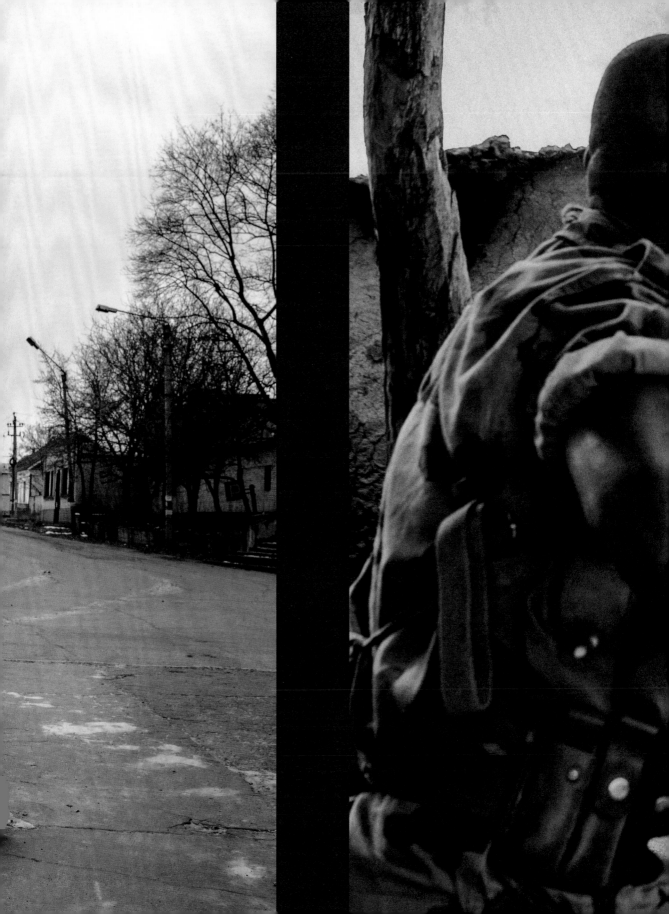

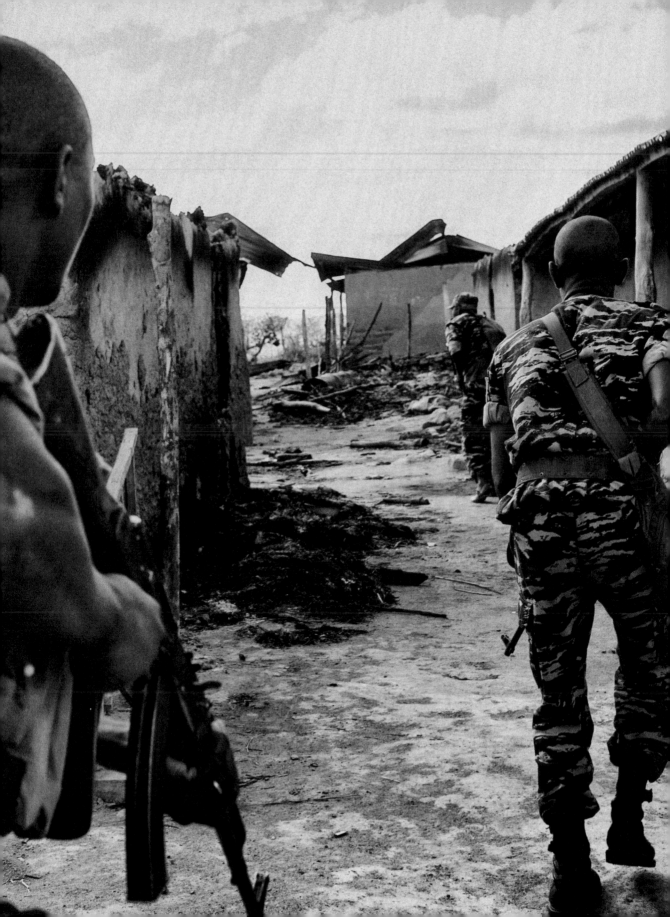

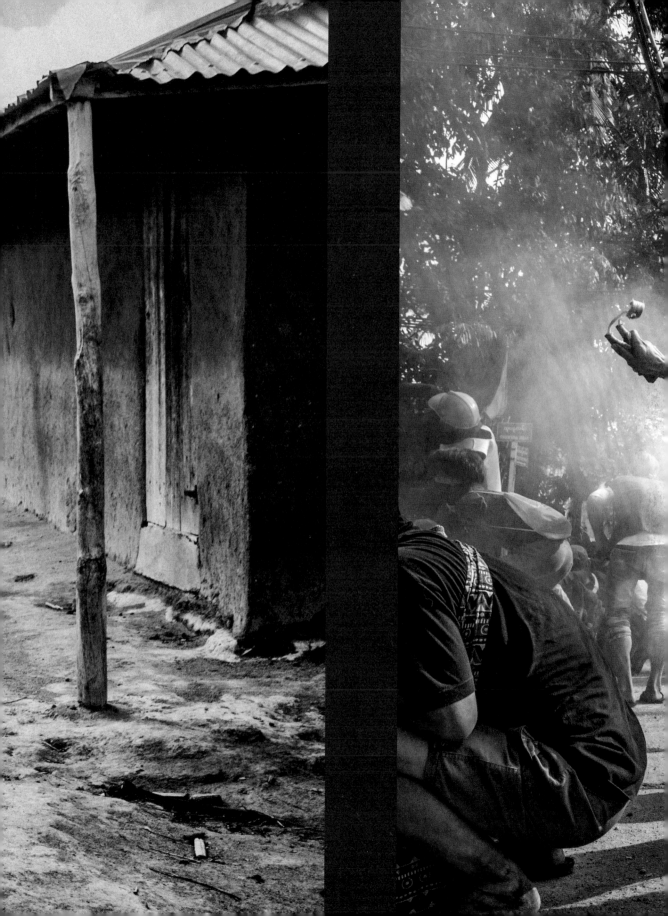

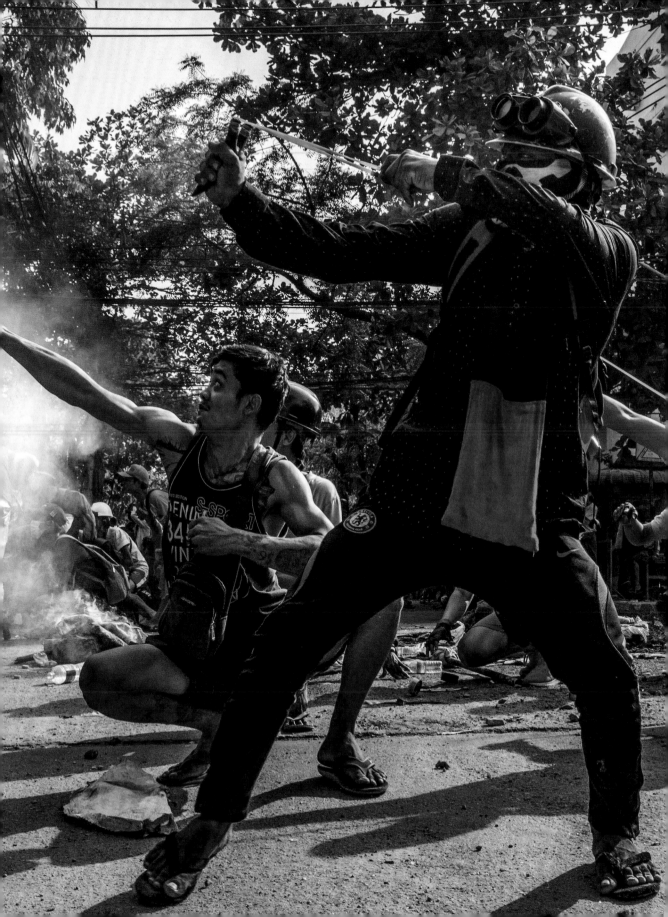

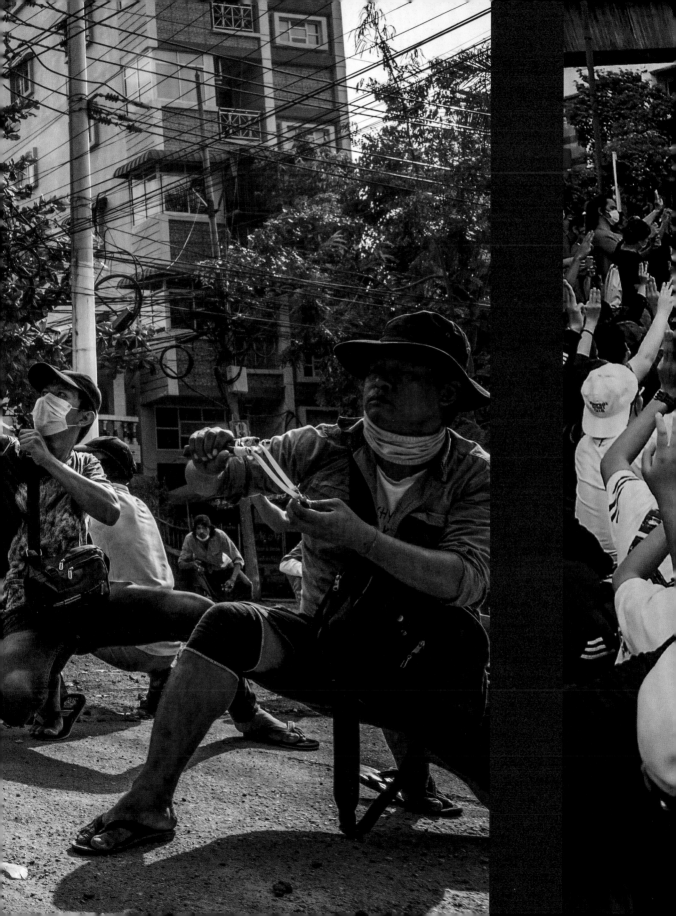

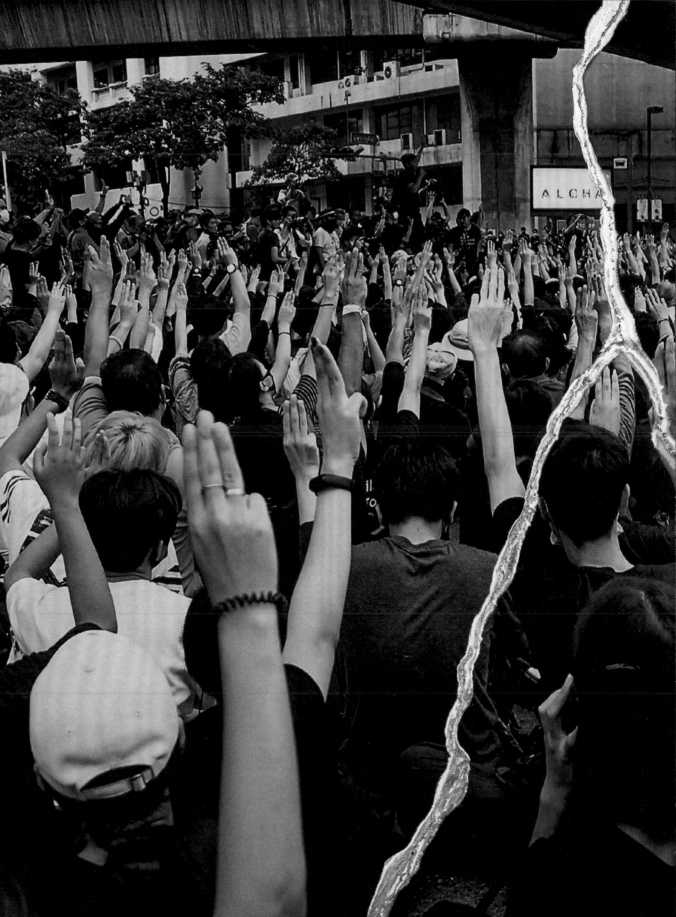

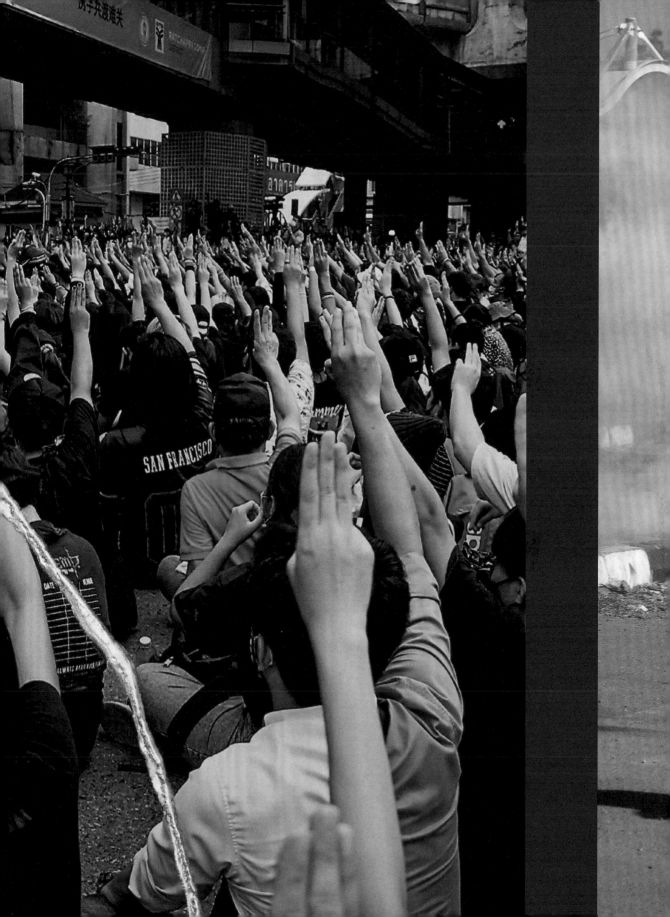

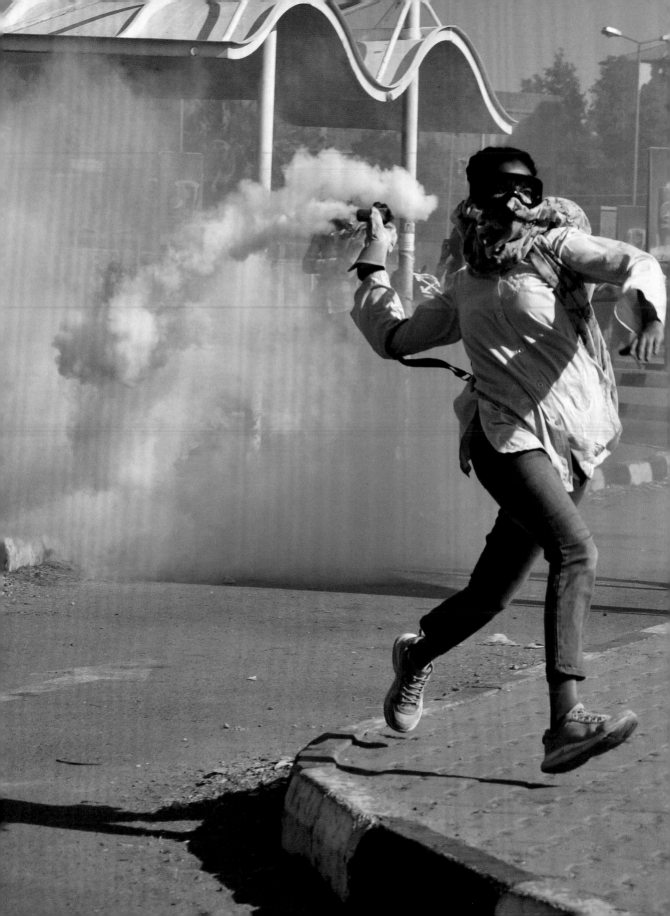

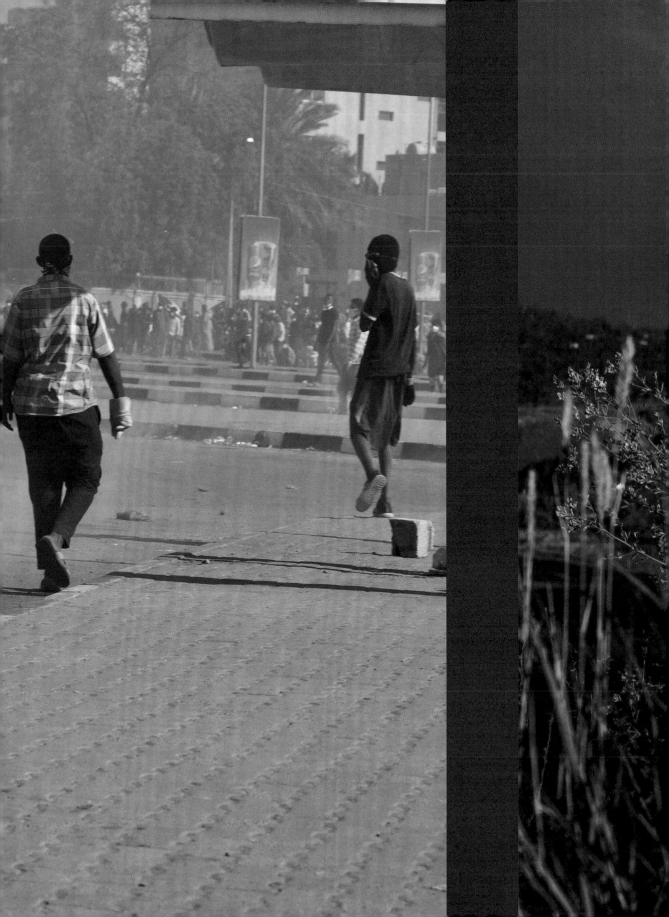

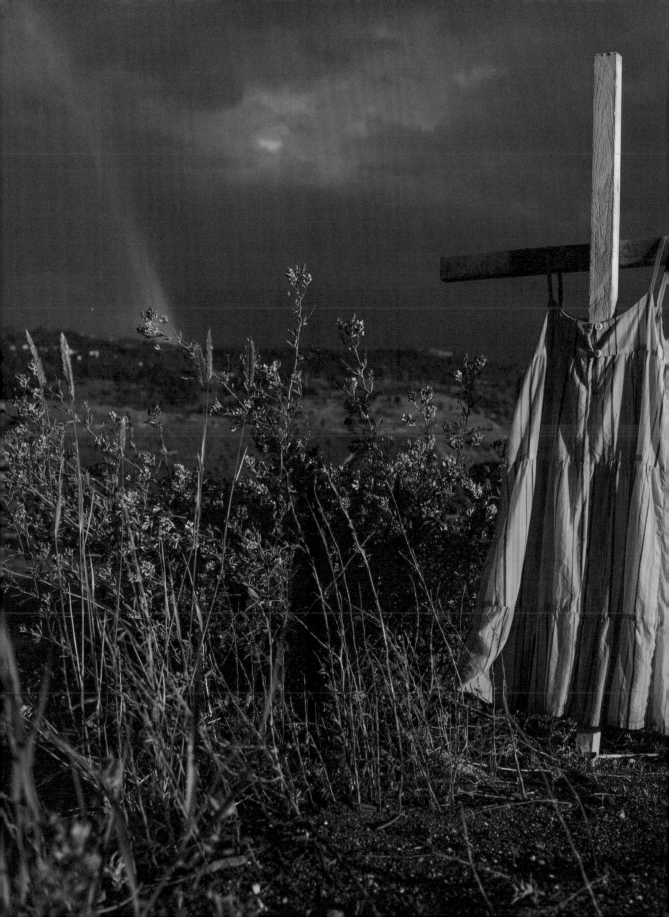

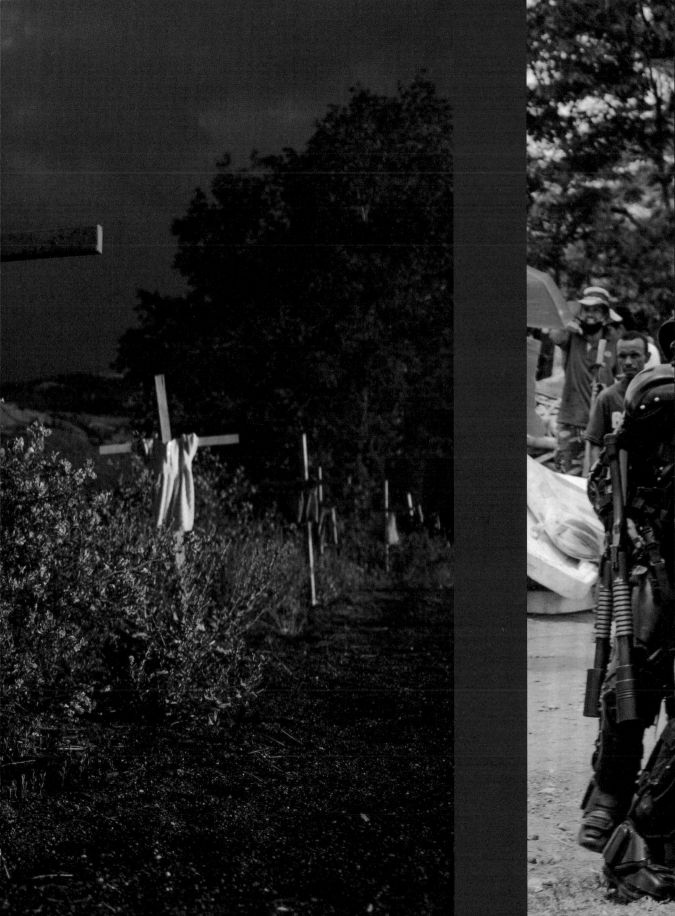

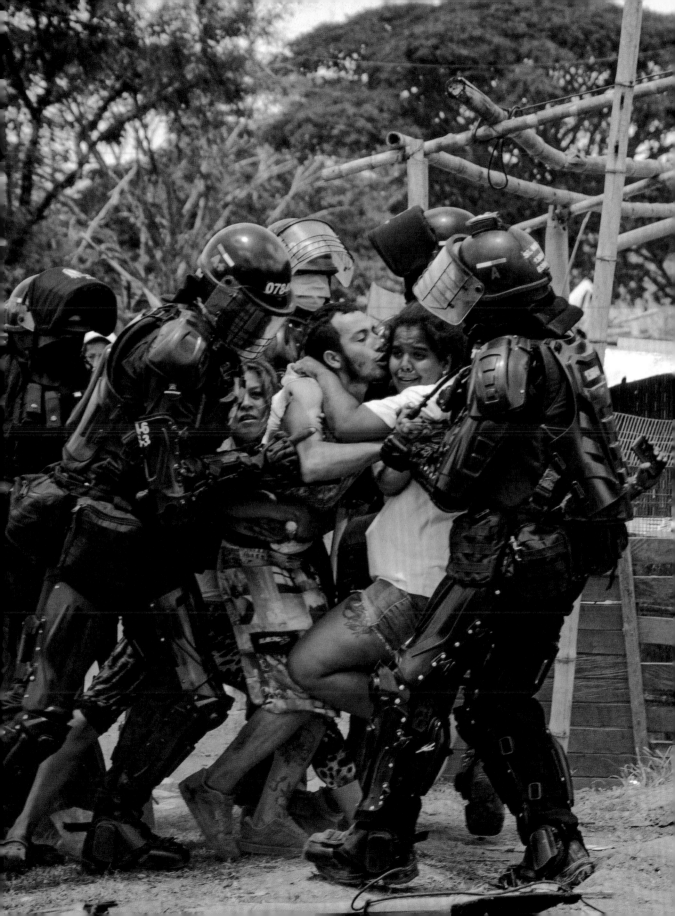

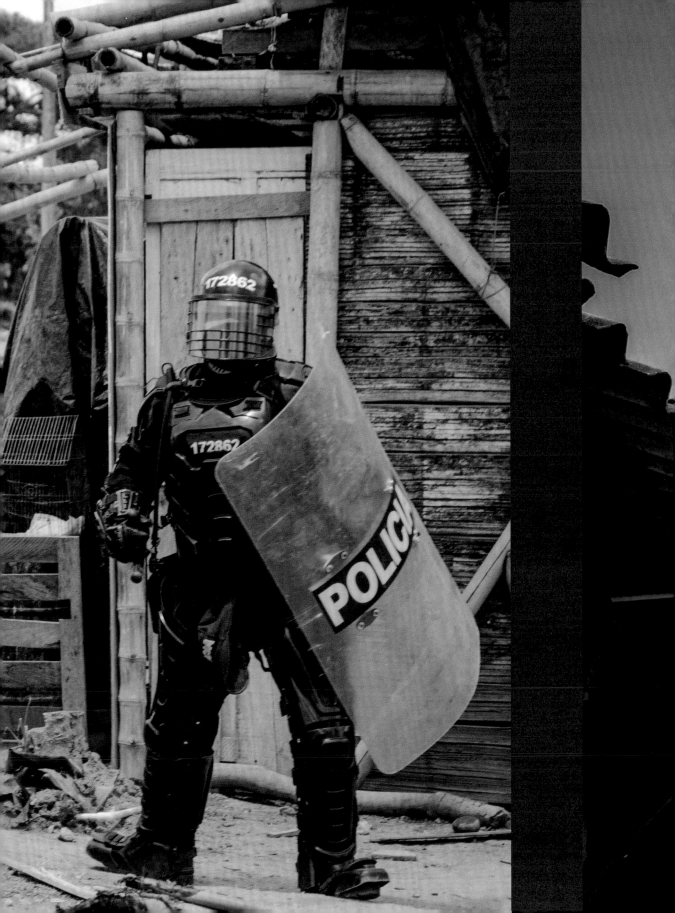

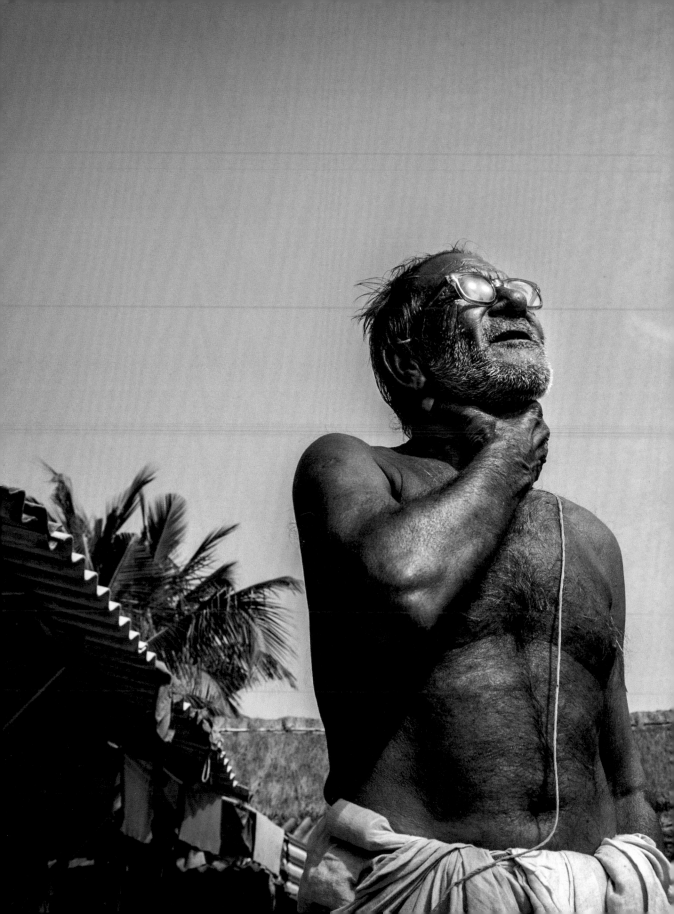

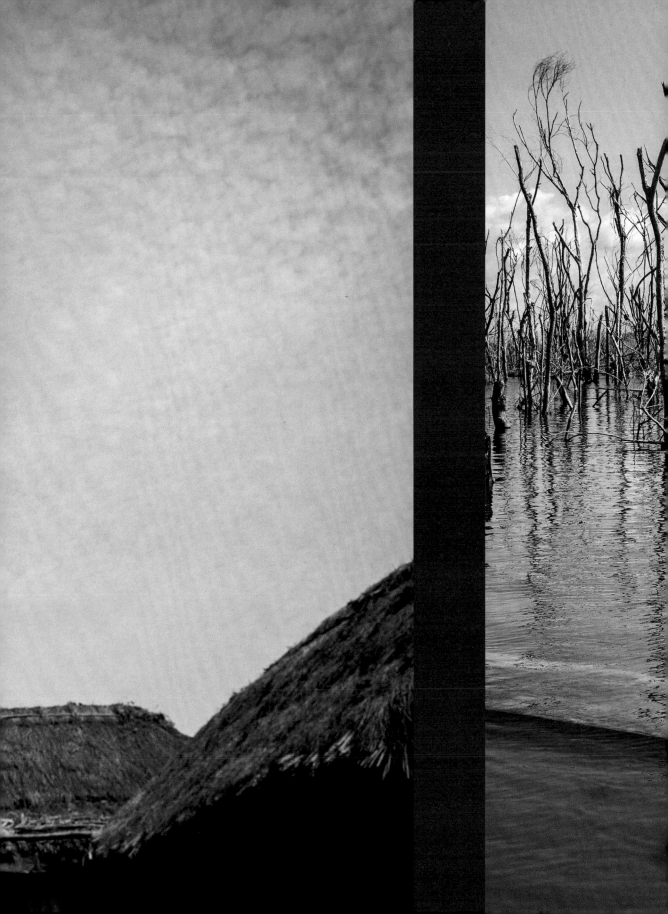

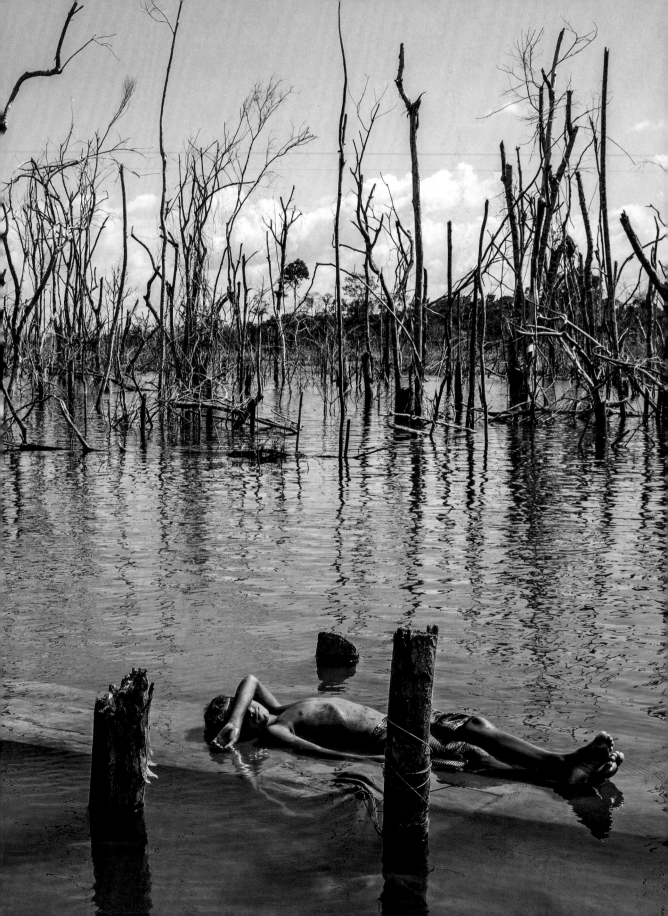

WORLD PRESS PHOTO 2022

Lannoo

CONTENTS

REGIONAL WINNERS

Africa

Asia

Europe

North and Central America

South America

Southeast Asia and Oceania

GLOBAL WINNERS

World Press Photo

REGIONAL JURY AND WINNING PHOTOGRAPHERS

GLOBAL JURY AND WINNING PHOTOGRAPHERS

The 2022 World Press Photo Contest works with six regions worldwide – Africa, Asia, Europe, North and Central America, South America, and Southeast Asia and Oceania. Entries are judged and awarded in the region in which the photographs and stories are shot, rather than according to the nationality of the photographer.

Each region has four format-based categories: Singles, Stories, Long-Term Projects and Open Format.

These categories welcome entries that document news moments, events and aftermaths, as well as social, political and environmental issues or solutions.

Singles
Single frame photographs shot in 2021. All winning singles are eligible for the World Press Photo of the Year award.

Stories
Stories containing three to ten single frame photographs, shot in either 2020 or 2021, with at least one photograph from 2021. All winning stories are eligible for the World Press Photo Story of the Year award.

Long-Term Projects
Projects on a single theme containing between 24 and 30 single frame photographs, shot over at least three different years, with a minimum of four photographs shot in 2021. All winning projects are eligible for the World Press Photo Long-Term Project Award.

Open Format
Projects using a range and/or mixture of formats such as polyptychs; multiple exposure images; photographic collages; interactive documentaries and short documentary videos. The main visual content of the project must be still photography, and the project must have been produced or first published in 2021. All winning projects are eligible for the World Press Photo Open Format Award.

Africa

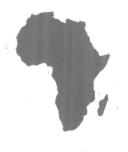

Asia

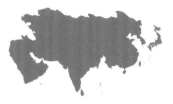

Europe

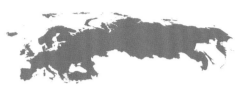

North and
Central America

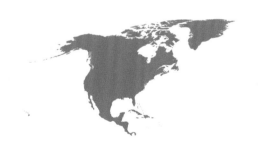

South
America

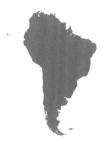

Southeast Asia
and Oceania

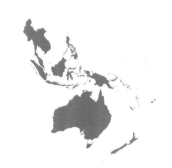

The sequence in which
the regions appear in this
book follows alphabetical
order in English.

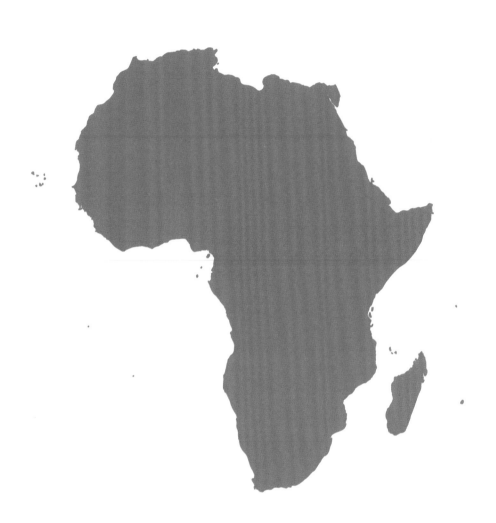

—

demanding
an
end

—

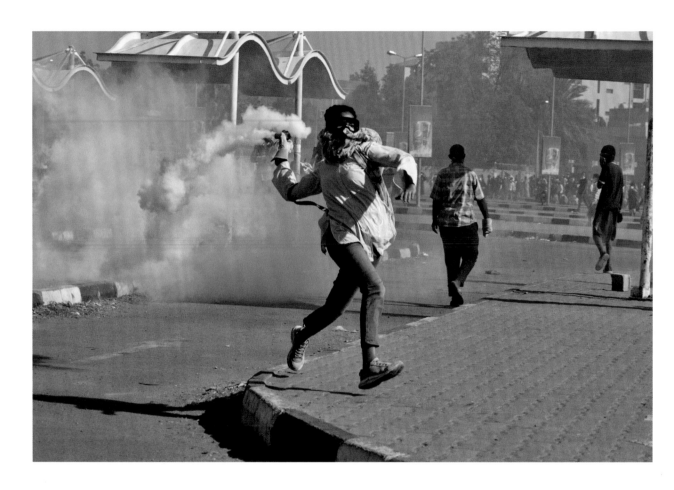

On 30 December, demonstrators marched through Khartoum, and the neighboring cities of Omdurman and Bahri, demanding that political power be transferred to civilian authorities. The protests were brutally suppressed. Reuters reported that five people were killed in the protests. The military had seized control in a coup on 25 October, dissolved the transitional government, and detained its prime minister, Abdalla Hamdok. The photographer is Sudanese and took part in early protests following the military coup, and then channeled his activities into photojournalism.

A protester throws back a tear-gas canister that had been fired by security forces, during a march demanding an end to military rule, in Khartoum, Sudan, on 30 December 2021.

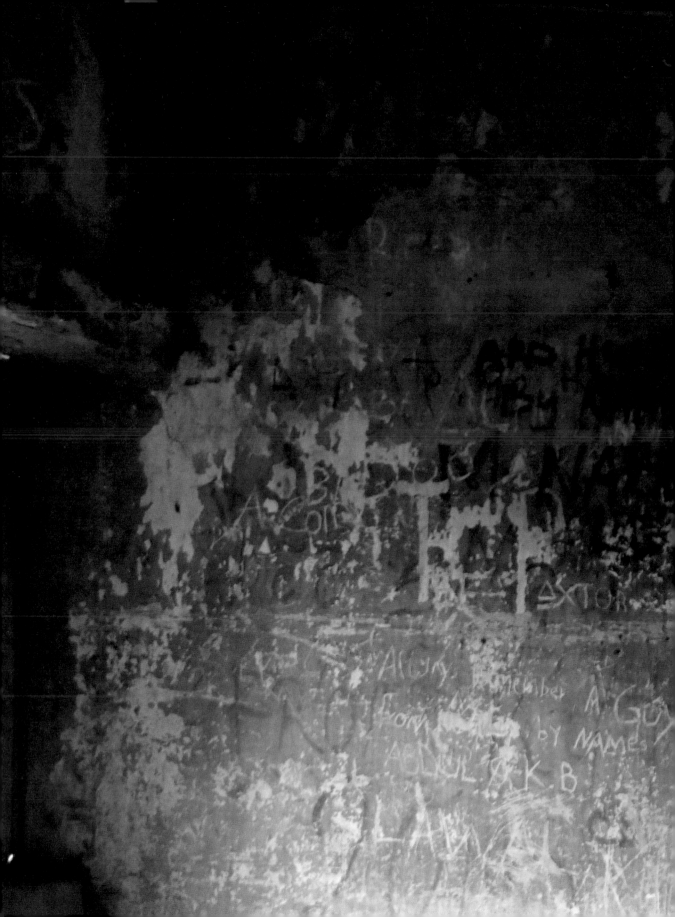

—

more
than
12
million
children

—

Kidnappings of students by Islamist groups and armed gangs continue to impact schools in Nigeria. These groups kidnap students to oppose Western secularism, to gain quick cash through ransoms, or to bargain for the release of imprisoned Boko Haram members. In 2014, the #BringBackOurGirls campaign led to international protests and wider discussions about this issue. However, kidnappings continue today without international media attention. According to Nigerian President Muhammadu Buhari, more than 12 million children – girls in particular – are traumatized and fear going to school. Names of the people in the photographs have been changed for safety reasons.

Hawa Munzali (not her real name) displays a photo of her 14-year-old daughter Faith (not her real name). Faith was among 140 students abducted from the Bethel Baptist High School, in Chikun, Kaduna State, northwest Nigeria, ten days earlier, on 5 July 2021.

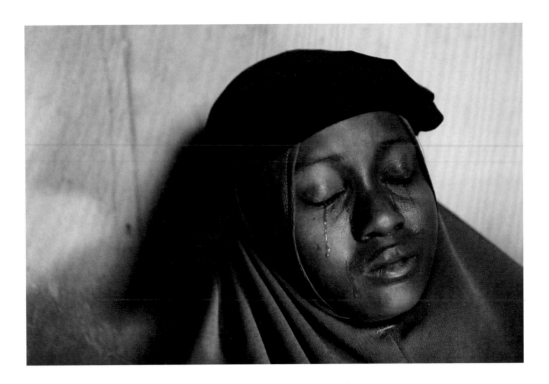

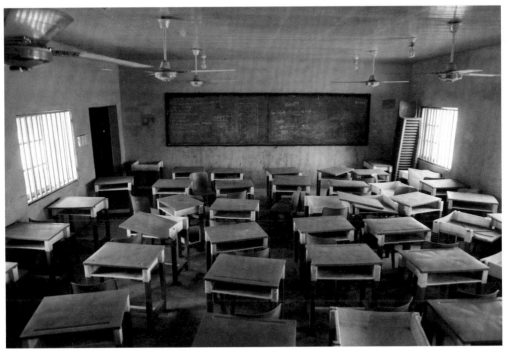

Aminah Labaran (not her real name) cries at home, in Jangebe, Zamfara State, northwest Nigeria, on 27 February 2021, the day after her two daughters were abducted. Gunmen, apparently from a bandit group, snatched 279 girls from dormitories in the middle of the night, at the Government Girls Secondary School in the village.

A classroom lies deserted at the Government Girls Secondary School, Jangebe, Zamfara State, northwest Nigeria, on 27 February 2021.

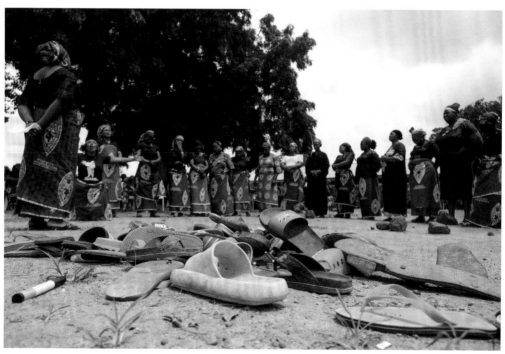

Objects lie abandoned after a kidnapping at the Government Secondary Science School, Kagara, Nigeria, on 18 February 2021. The day before, gunmen had abducted an estimated 27 students.

Sandals belonging to kidnapped students remain lying on the ground at the Bethel Baptist High School, in Chikun, Kaduna State, northwest Nigeria, on 14 July 2021.

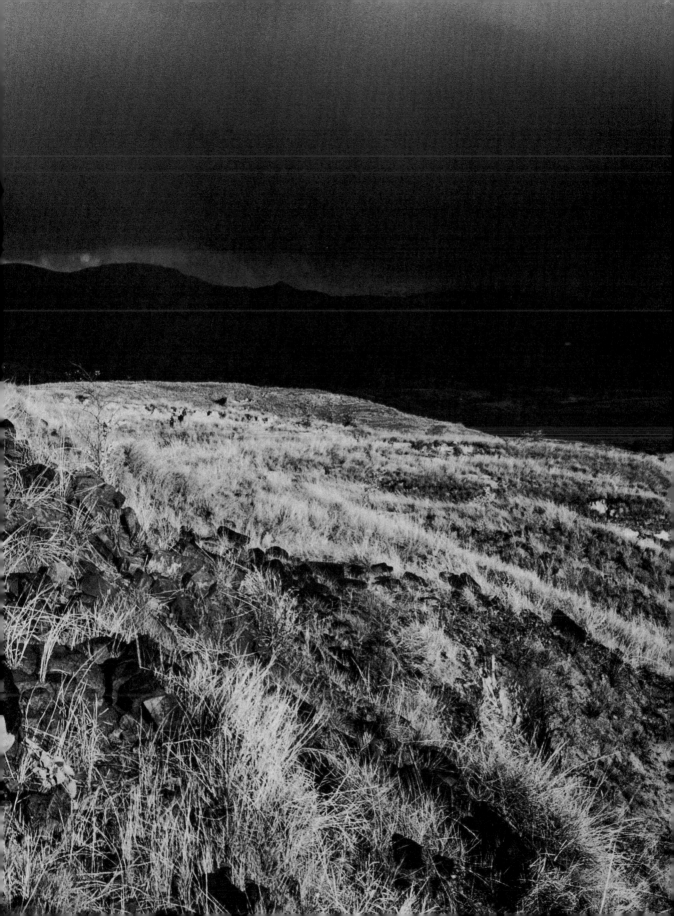

—

highly
prized
humped
cattle

—

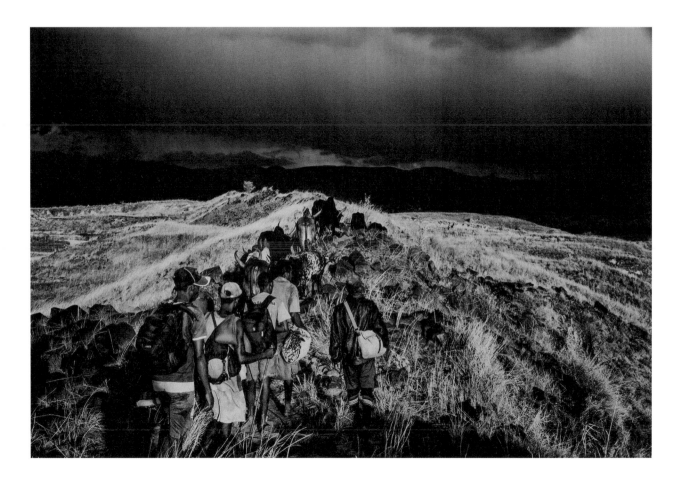

For decades, the rural population of southern and western Madagascar have faced violence and the daily theft of their zebu, highly prized humped cattle, by groups of men called *dahalo* (which roughly translates as 'bandits'). Zebu are used in dowry payments, rituals, and are much valued for their meat. Since the 1970s, mounting economic inequality and a food crisis has exacerbated zebu theft and violence, with frequent deadly clashes between rural communities and groups of *dahalo*. Government intervention against zebu theft has been harsh, and in 2014, Amnesty International accused Malagasy security forces of indiscriminate acts of violence.

Louis Kasay, a prominent zebu breeder, along with eight of his herdsmen and 13 zebu, descend the eastern slope of the Tsingy Plateau in Bemaraha, Madagascar, on 24 November 2020, on their ten-day walk to the zebu market in Tsiroanomandidy.

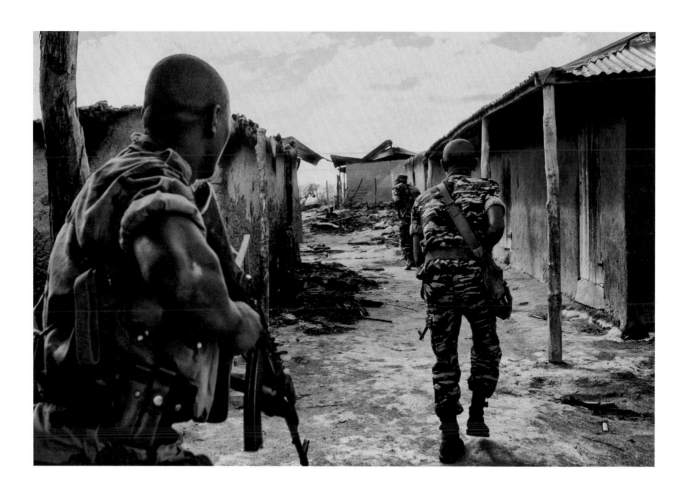

Security forces enter the village of Ambatotsivala, Madagascar,
in an operation against cattle thieves, on 1 June 2014.
Ambatotsivala and a neighboring village, Andranondambo,
had been involved in numerous retaliatory attacks, after an initial
raid by men from Ambatotsivala to steal zebu, on 7 May.
Some 22 people were killed and 2,294 were left homeless in
the attacks, according to reports in local media.

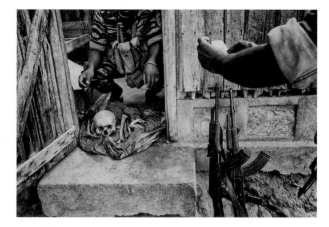

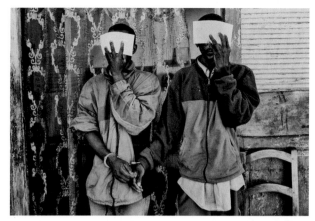

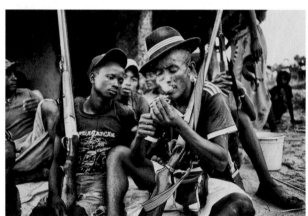

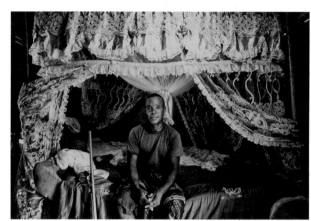

Security forces patrol the ruins of the village of Andranondambo, in southern Madagascar, on 1 June 2014. The village had been completely destroyed during attacks by *dahalo* zebu thieves from a neighboring village, Ambatotsivala.

Etosoa Mihary (left) and Tsiry Tam (right), inhabitants of the village of Ambatotsivala, considered by authorities to be a zebu-raiding village, stand after being arrested on suspicion of the murder of an inhabitant of a neighboring village in Amboasary Sud, Madagascar, on 3 June 2014.

Men smoke local tobacco in the village of Mataviakoho in west-central Madagascar, on 28 November 2020. The village is reputed to be the base of the notorious head of a group of cattle thieves.

Jean Maximis Nonon sits in his bedroom in Mataviakoho, North Menabe, Bongolava, Madagascar, on 25 November 2020. Military authorities see Nonon as one of the most dangerous *dahalo* leaders in the region. Nonon refuses to be considered a *dahalo*.

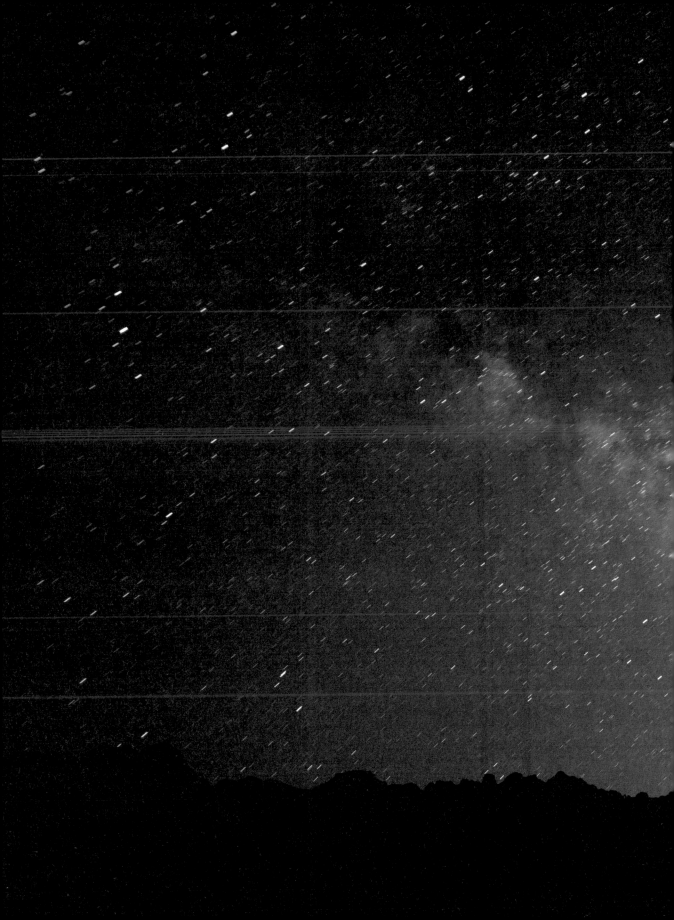

—

to
protect
their
land

—

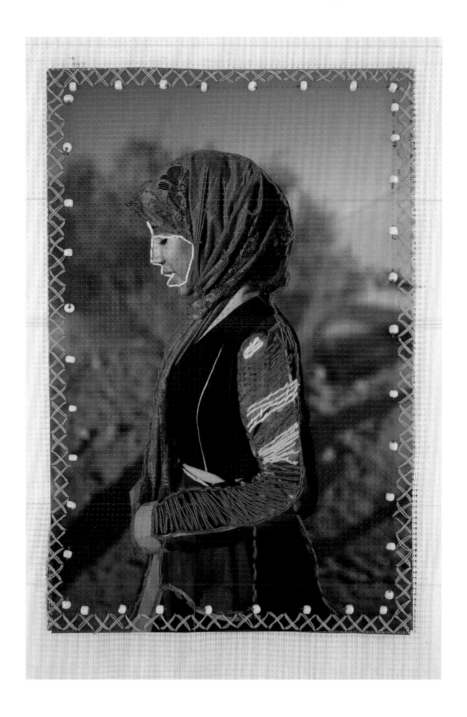

Bedouins have inhabited the Sinai peninsula for centuries and have long faced discrimination. They are still perceived as having been collaborators during the Israeli occupation of the Sinai from 1967 to 1982, when the Bedouins remained to protect their land. Bedouin women have also been misrepresented and stereotyped in Egyptian media. Challenging these stereotypes in the project, portraits of women from the community, printed on fabric, were embroidered by the women themselves, and men from the community contributed with handwritten poetry. The photographer is an activist and has been an active member of the community for the past 15 years.

A photograph of Nadia (20), embroidered by
her and her cousin Mariam (19), in St. Catherine,
South Sinai, Egypt, on 8 December 2019.

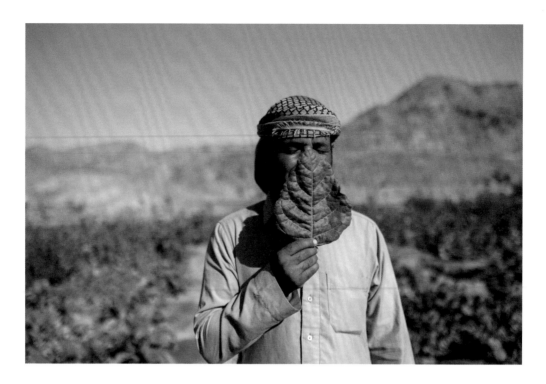

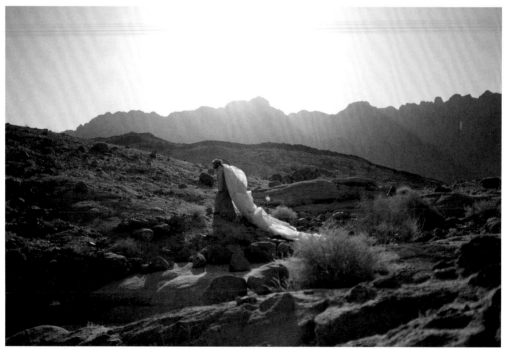

Seliman holds a khodary (*Nicotiana rustica*) leaf in his garden in Gharba Valley, South Sinai, Egypt, on 1 October 2020. Seliman manages an eco-lodge in the valley with his cousins. Because of COVID-19 the eco-lodge had fewer guests, so Seliman redirected his focus on the family garden.

Seliman drags a plastic sheet to dry his plant harvest in St. Catherine, South Sinai, Egypt, on 1 October 2020.

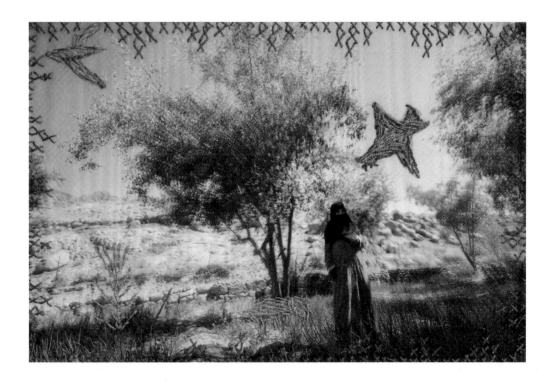

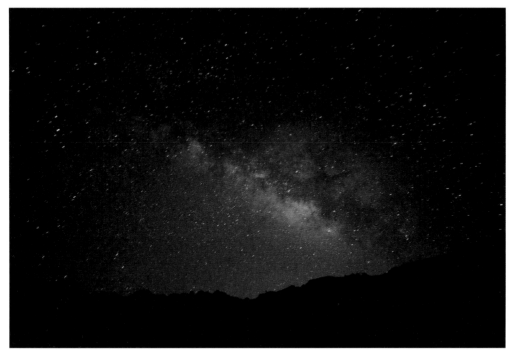

Hajja Oum Mohamed (53), who embroidered her own portrait, in her garden in Gharba Valley, South Sinai, Egypt, on 7 April 2017.

The Milky Way is seen above Sheikh Awad village on the night of 7 April 2017. Bedouin people have long used the stars to guide themselves through the desert.

—

a
fragile
ceasefire

—

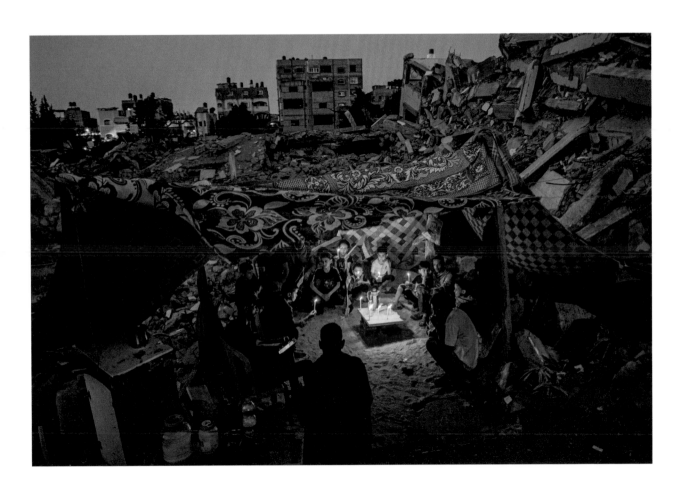

An 11-day conflict broke out on 10 May, following rising tensions over threatened evictions in the disputed Sheikh Jarrah district in East Jerusalem, and clashes at the Al-Aqsa Mosque compound – one of Islam's holiest sites – in Jerusalem's Old City. Conflict spread to involve other cities in Israel and Palestine, and rockets were fired across the borders with Syria and Lebanon, in what became the heaviest outbreak of fighting since the 2014 Gaza War. UNICEF stated that around 500,000 children in Gaza could be in need of psychological support following the 2021 conflict.

Palestinian children gather with candles during a fragile ceasefire in Beit Lahia, Gaza, Palestine, on 25 May 2021, after a protest by children in the neighborhood against attacks on Gaza.

in
limbo

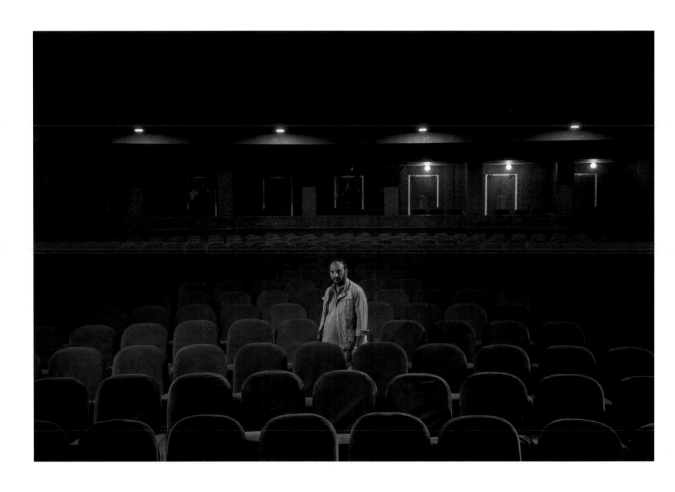

Culture can also be a casualty of war. Following the Taliban takeover of Afghanistan in August 2021, the government-owned Ariana Cinema in Kabul remained closed, its staff in limbo, waiting to hear whether the Taliban would allow films to be screened. Male staff still arrive for work daily, in the hope they will eventually be paid, but Asita Ferdous – the cinema's first female director – was not allowed in. In early 2022, the cinema remained closed, and women were no longer allowed to be employed there.

Gul Mohammed, who works as an usher in the Ariana Cinema in Kabul, Afghanistan, poses for a photograph on 4 November 2021, nearly three months after the Taliban closed the cinema.

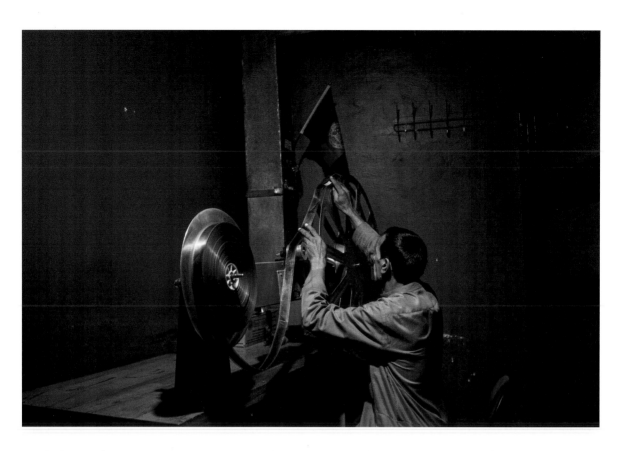

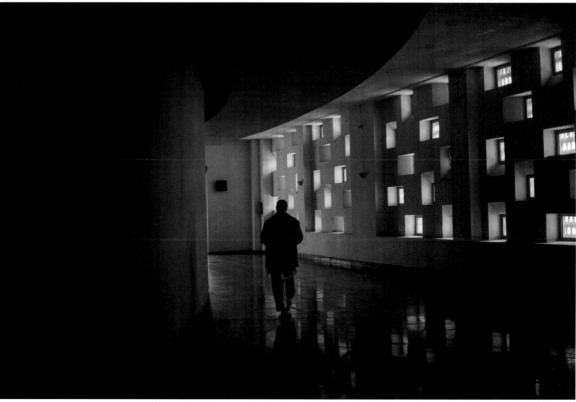

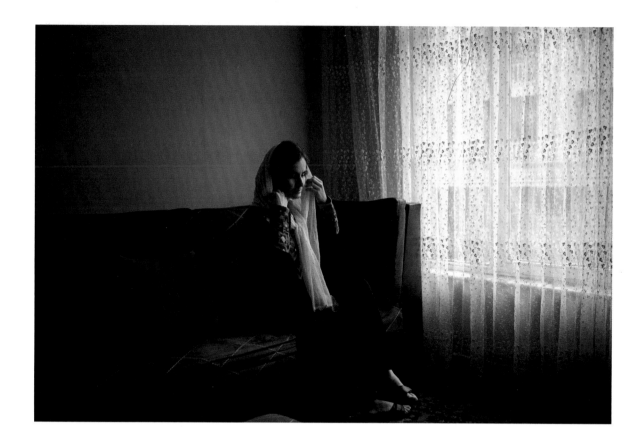

Rahmatullah Ezati inspects a roll of film for damage, in the projection room of the Ariana Cinema in Kabul, Afghanistan, on 8 November 2021.

Asita Ferdous, director of the government-owned Ariana Cinema in Kabul, Afghanistan, sits at home on 10 November 2021, nearly three months after the Taliban ordered female government employees to stay away from their workplaces.

A staff member walks through empty hallways at the Ariana Cinema in Kabul, Afghanistan, on 4 November 2021.

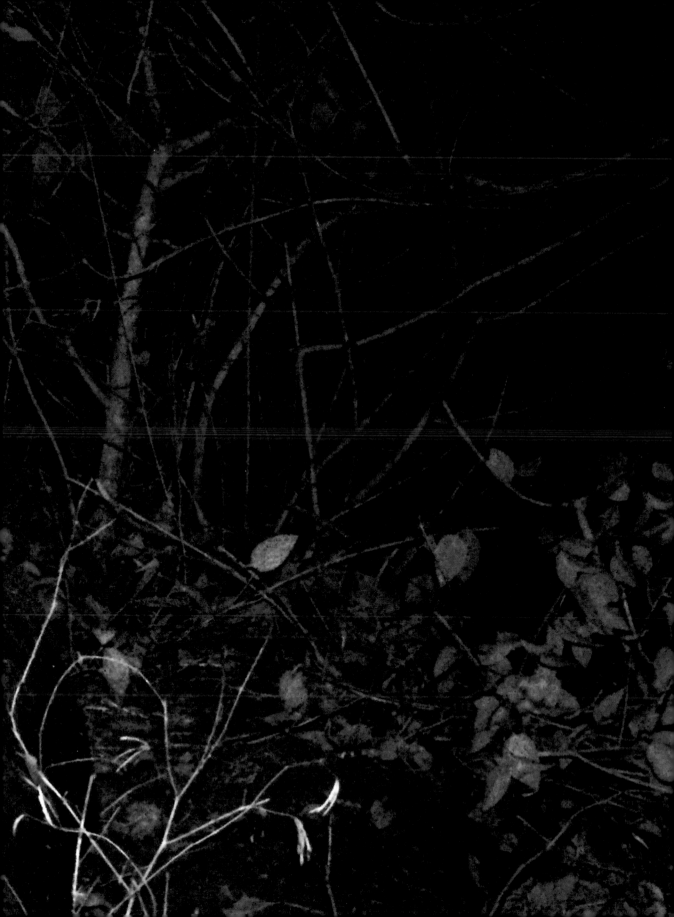

surviving
in
the
wild

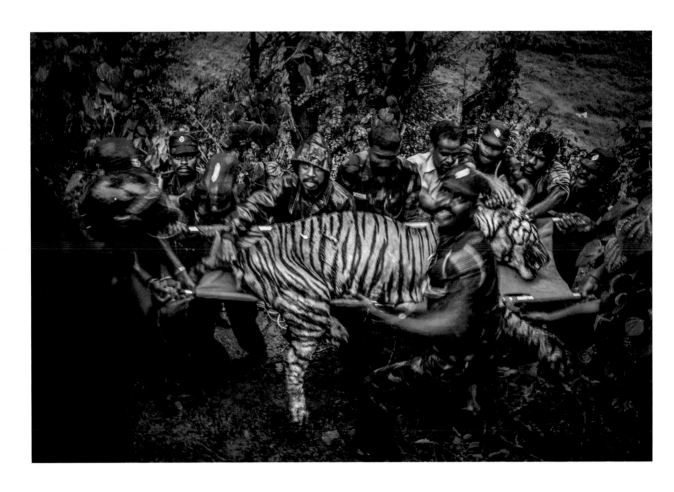

In India, Bengal tigers (*Panthera tigris tigris*) are considered endangered, with up to 3,000 surviving in the wild. Human settlement, cultivation, and urban development are encroaching on tigers' natural habitat and reducing their prey base. Villages on the perimeters of tiger sanctuaries and reserves are often home to Indigenous communities, who depend on livestock, farming, or the forest for their livelihoods. Conflict arises when tigers kill livestock and occasionally humans, which although rare, usually occurs when angry groups surround tigers who have entered settlements.

A ten-year-old male tiger lies tranquilized as it is shifted to a cage to be removed, after entering a village and killing cattle, close to the town of Valparai, near the Anamalai Tiger Reserve, Tamil Nadu, India, on 27 April 2012.

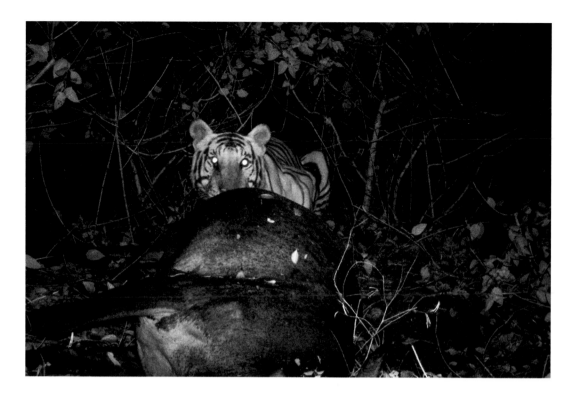

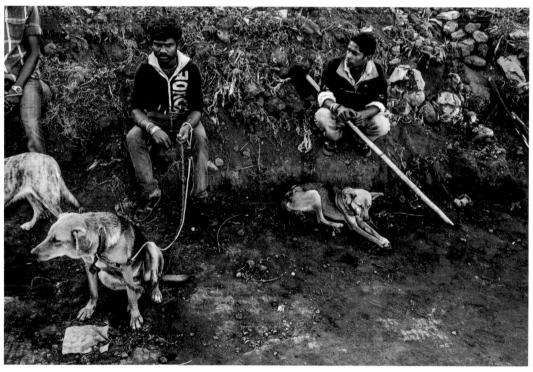

A motion sensor camera captures the image of a tiger that has entered a village and killed livestock, in Tamil Nadu, India, 28 June 2018.

Members of a local community search for a tiger that had killed three people within a week around a village near Ooty, in Tamil Nadu, India, 12 January 2014. The tiger was eventually shot dead.

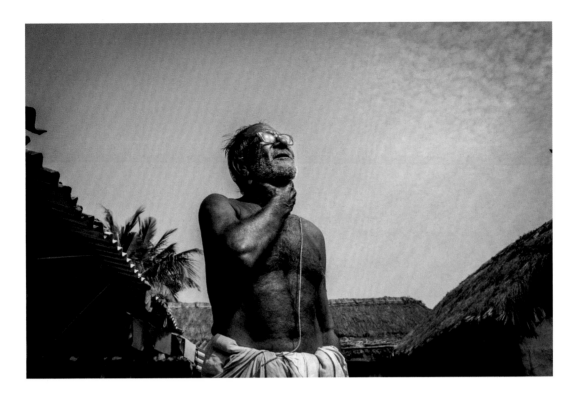

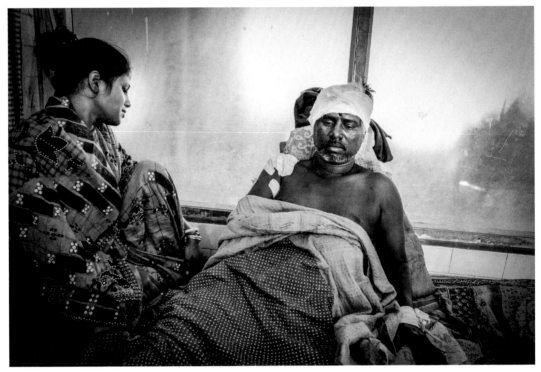

Bhuthari, a fisherman, explains how he was attacked by a tiger while collecting crabs, in the forest buffer zone around the Sundarban Tiger Reserve, in the delta region of West Bengal, India, 4 December 2012.

Manoranjan Biwas lies seriously injured on 3 December 2012, after being attacked by a tiger when he was collecting crabs inside the forest zone of the Sundarban Tiger Reserve, the delta region of West Bengal, India.

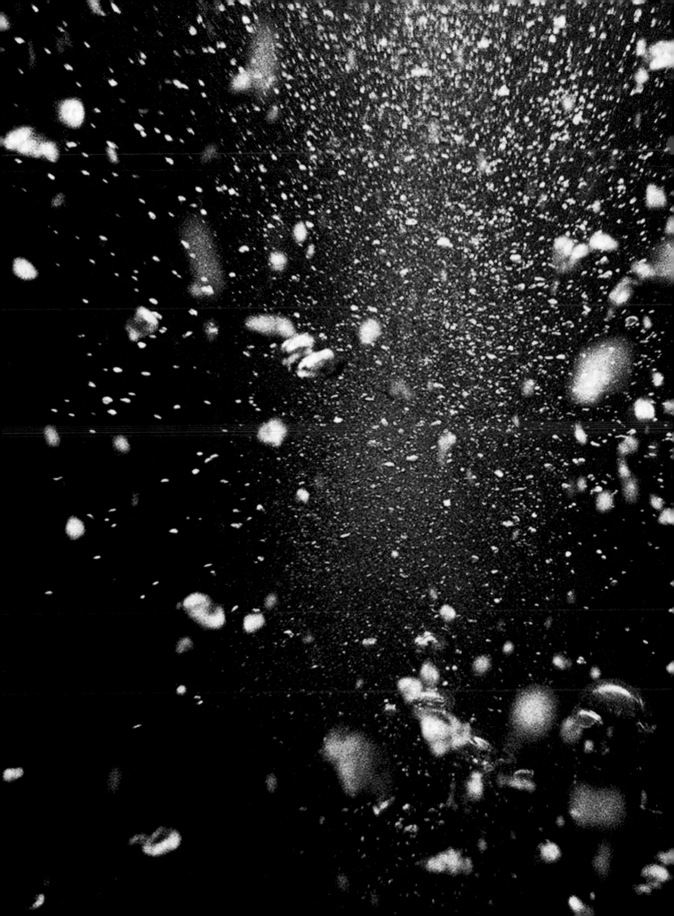

—

memories
infiltrate
dreams

—

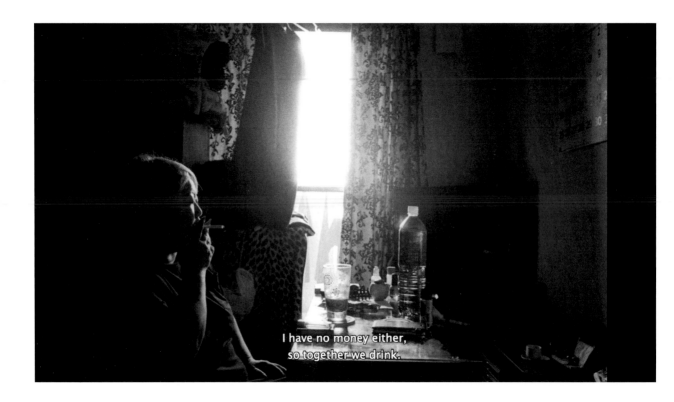

Blue Affair is a contemplative experimental documentary film based on the photographer's experiences of visiting Koza (officially known as Okinawa City), Japan, and how places and people revisit him in recurring dreams. The documentary is based on these dreams, and is composed of still images taken by Okahara in Koza over the course of three years, and narrated by the photographer. The video explores how memories infiltrate dreams, and asks us to reconsider the relationship between dreams and lived reality.

Scan the QR code
to watch the video.

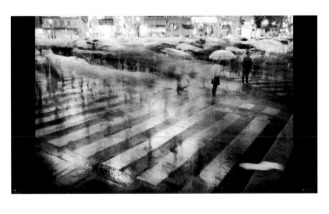

blue affair

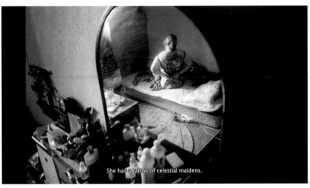

She has a tattoo of celestial maidens.

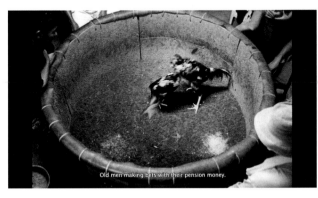

Old men making bets with their pension money.

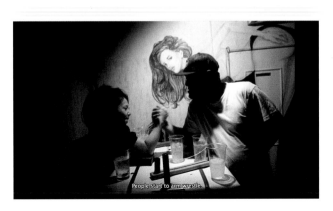

People start to arm wrestle.

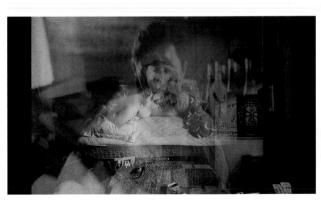

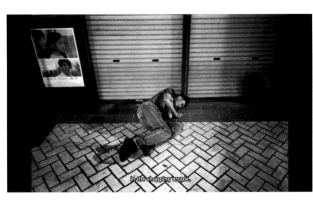

In the shopping arcade.

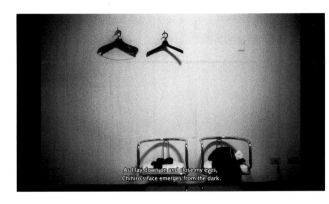

As I lay down on and close my eyes,
Chihiro's face emerges from the dark.

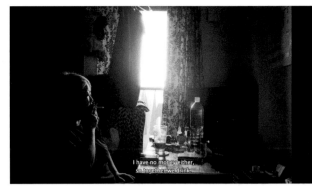

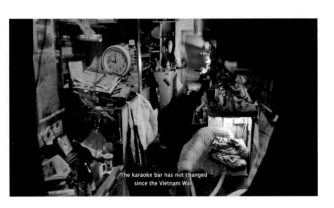

There is a building
built after World War II.

The patrons have known
each other for a long time.

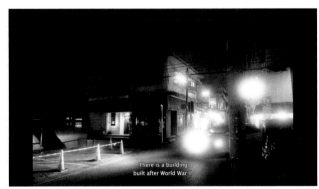

The karaoke bar has not changed
since the Vietnam War.

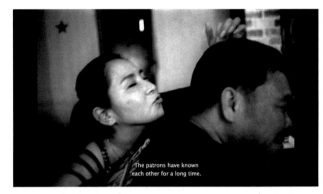

When I look back,
all I see is a closure sign.

I have no money either,
so together we drink.

—

for the
whole
village

—

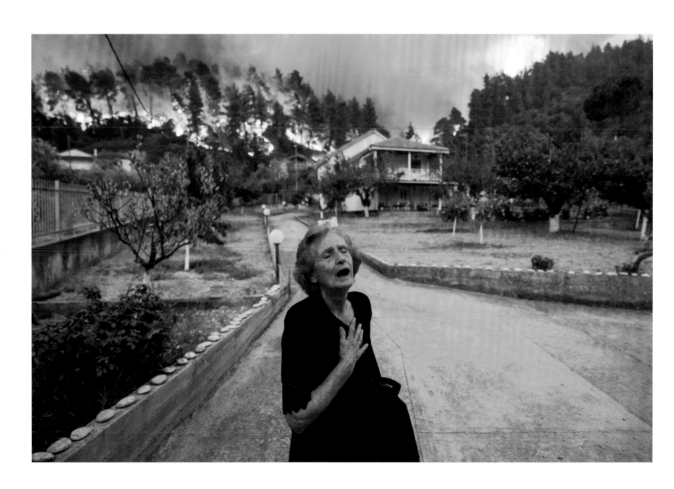

Wildfires broke out on Evia – Greece's largest island after Crete – in July and August, following the hottest weather Greece had experienced in 30 years. The megafire took almost two weeks to bring under control. Local reports pointed to global heating and other contributing factors, such as rural depopulation, budget cuts in the fire brigade, and changes in fire management strategies. Local resident Panayiota Kritsiopi is quoted as saying: "At that moment I was shouting not only for myself. For the whole village." In the end, her home remained intact.

Panayiota Kritsiopi cries out as a wildfire approaches her house in the village of Gouves, on the island of Evia, Greece, on 8 August 2021.

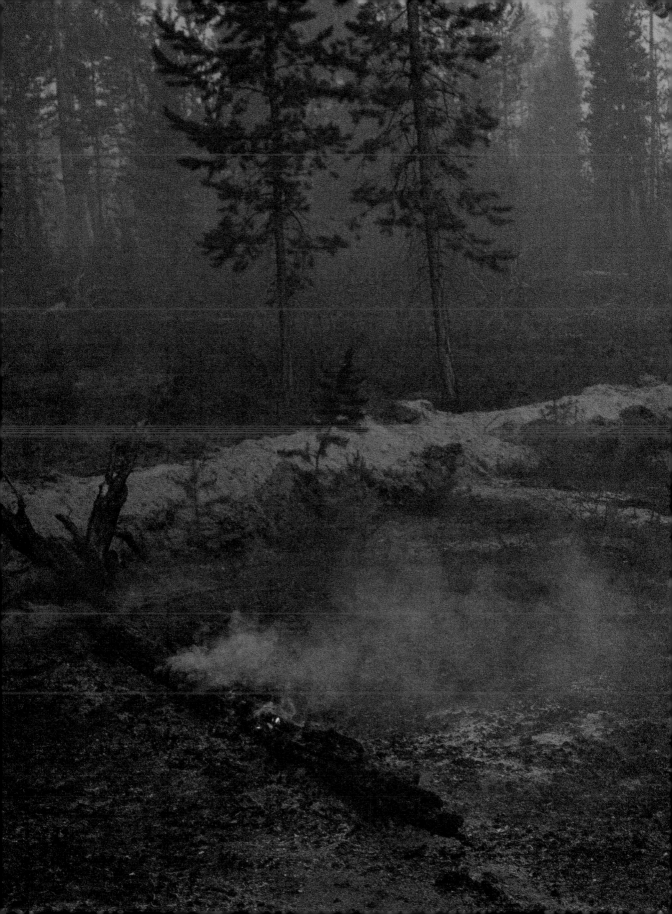

—

three
times
as
fast

—

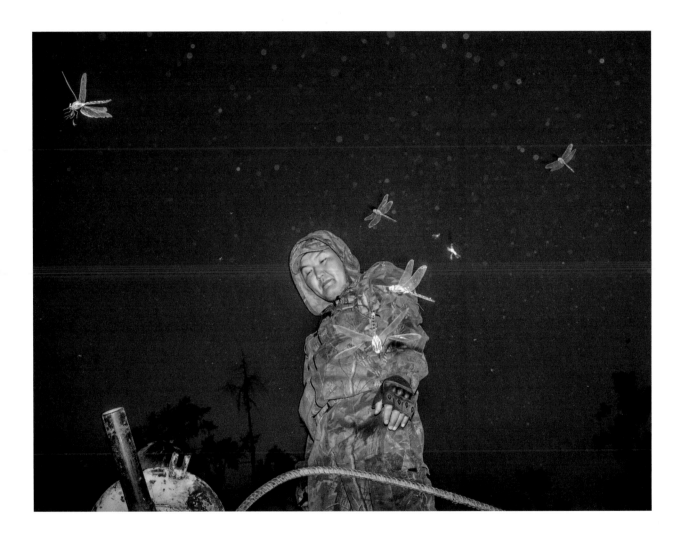

Sakha, also known as Yakutia, which extends over more than three million square kilometers in the far northeast of the Russian Federation, experienced devastating wildfires, severe smoke pollution, and melting of its permafrost in 2021. According to Greenpeace Russia, by mid-August 2021 more than 17.08 million hectares had been ravaged by fire – larger than the areas burned by fires in Greece, Turkey, Italy, the US and Canada combined. The Arctic Monitoring and Assessment Programme reports that the Arctic is heating three times as fast as the global average.

Dragonflies catch mosquitoes, while a local volunteer firefighter pumps water from a lake into a water truck before driving to a forest fire near Bulgunnyakhtakh, Sakha, Siberia, Russia, 9 July 2021.

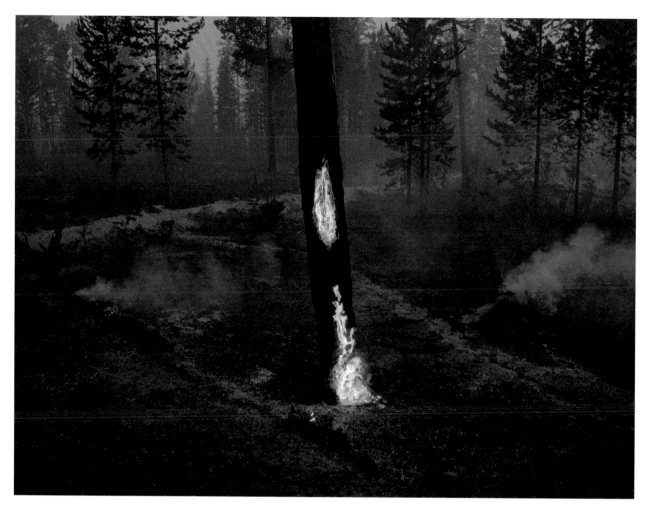

Trees burn during a forest fire near Kürelyakh, Sakha, Siberia, Russia, 5 July 2021.

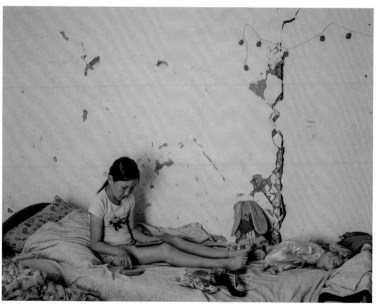

Veronika in her room in Yunkyur, in southern Sakha, Siberia, Russia, on 27 June 2021. As with other village houses, the foundations of her family's home are being undermined by thawing permafrost. The floor is sinking, cracks run through the walls, and the basement where the family stored potatoes has collapsed.

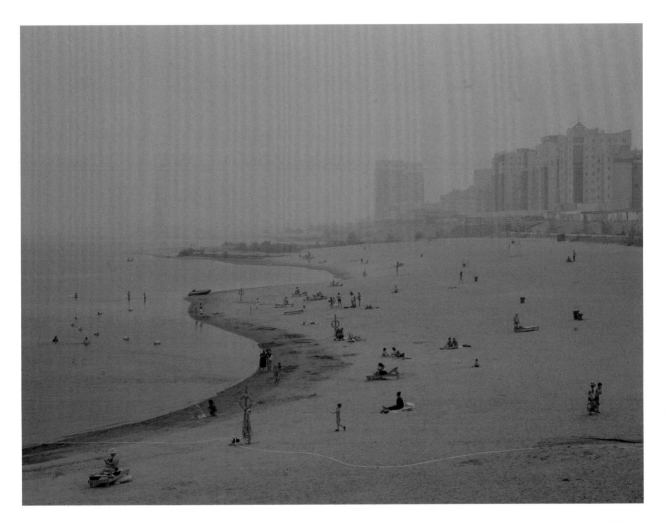

Despite a warning from local authorities for citizens to stay indoors to avoid choking fumes, some people in the capital Yakutsk passed time on the beach, Yakutsk, Sakha, Siberia, Russia, on 17 July 2021.

Local firefighting volunteers take a break for food in Magaras, central Sakha, Siberia, Russia, on 1 July 2021.

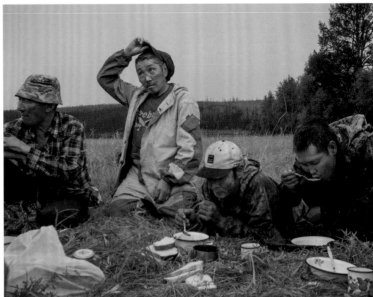

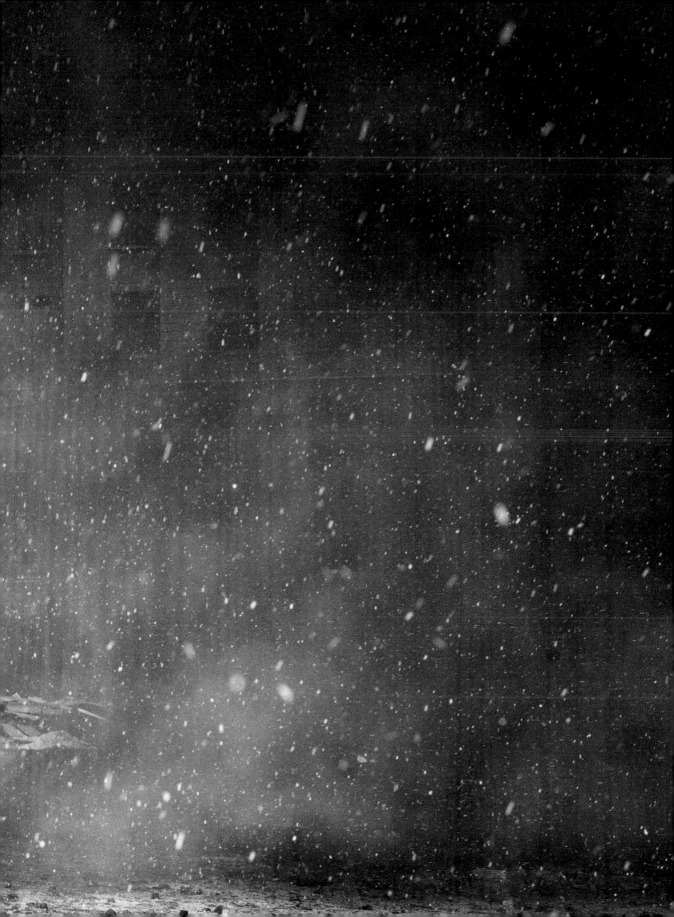

—

a
volatile
situation

—

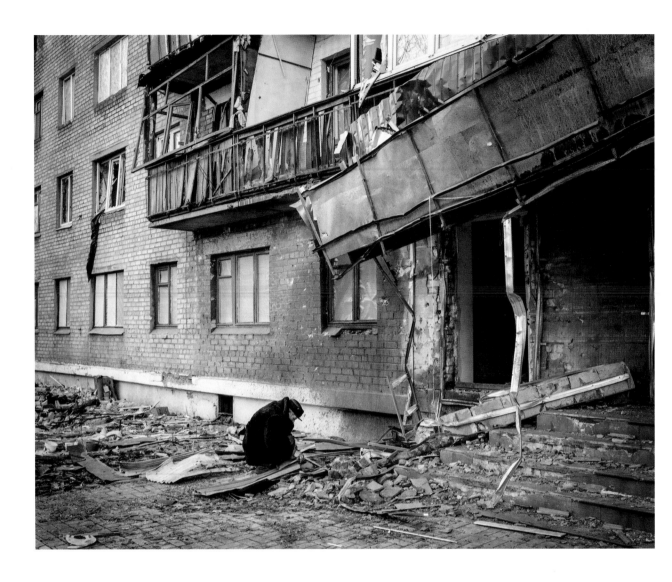

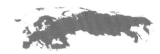

Photographed between 2013-2021, this project looks at the longer-term context leading to the 2022 war in Ukraine. Tensions between the east and west of Ukraine were exacerbated in 2014 when Kremlin-backed forces occupied the Crimean peninsula and separatists in the eastern regions of Donetsk and Luhansk established self-proclaimed people's republics, a status not officially recognized by most of the international community. Tensions continued and, in February 2021, Russia began increasing its military forces on Ukraine's borders. In December, Russian President Vladimir Putin laid out a set of security demands, including that Ukraine be permanently barred from joining NATO, and the already volatile situation intensified. On 21 February 2022, President Putin formally recognized the independence of the Donetsk People's Republic (DNR) and the Luhansk People's Republic (LNR). Three days later, Russia launched a full-scale invasion of Ukraine.

Alexi Stipanovich crouches outside the building where he lives, which was hit by shells in fighting between Ukrainian and pro-Russian forces, in Debaltseve, Donbas, Ukraine, on 11 March 2015.

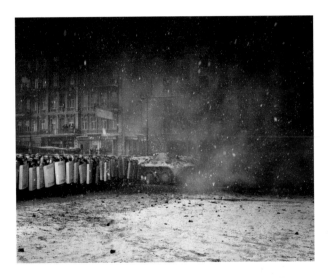

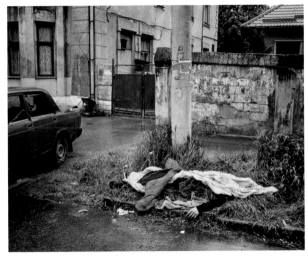

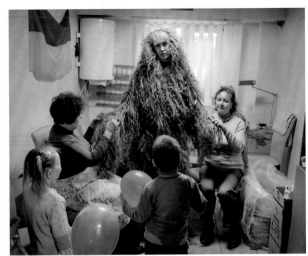

Anti-riot forces form a barrier on Hrushevskoho Street, Kyiv, Ukraine, on 22 January 2014. Violent confrontations had taken place between anti-riot units and pro-EU protesters since the previous day, leaving at least four people dead and hundreds wounded.

The body of a man lies in front of a police station, in Mariupol, Ukraine, on 9 May 2014, following a fight between separatist militia and the Ukraine National Guard.

Vassili Kissilov lies in bed in Kodema, Donetsk, Ukraine, on 26 November 2019. Kissilov was driving his tractor in a field near his village on 24 April 2015, when he hit a landmine. His legs were badly burned and he lost two fingers and two toes.

Women make camouflage gear for snipers, at the Novy Mariupol Center, an organization that collects equipment for Ukrainian soldiers, in Mariupol, Ukraine, on 26 September 2014.

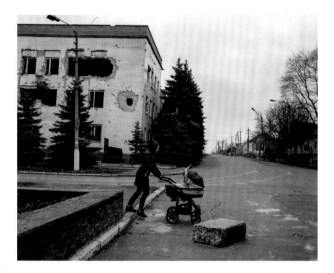

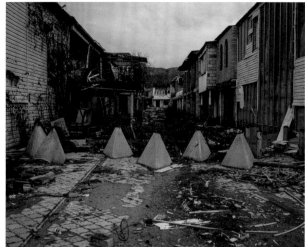

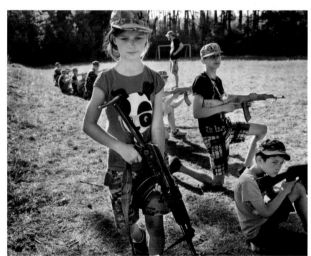

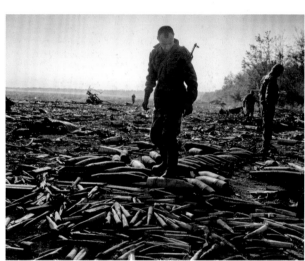

A woman pushes a baby carriage across Lenin Street, past a police station destroyed during fighting in 2014, in Marinka, Donbas, Ukraine, on 22 February 2018.

Fortification bollards lie across a street in Shyrokyne, Donetsk, Ukraine, on 29 November 2021. Once a popular resort on the Sea of Azov, Shyrokyne became a battleground in the 2014-2015 conflict between separatists and Ukrainian forces.

Children undergo military training at a summer camp for children aged from 7 to 18, in suburban Kyiv, Ukraine, on 14 July 2016. The camp is one of a number organized by the Azov Battalion, a radical nationalist militia, now part of the National Guard, that leads the fight against pro-Russian separatists in eastern Ukraine.

DNR soldiers search a battlefield for any live ammunition left behind by Ukrainian troops after August clashes with separatists, in Amvrosiivka, Donbas, Ukraine, on 6 October 2014.

—

epicenter
for
fake news

—

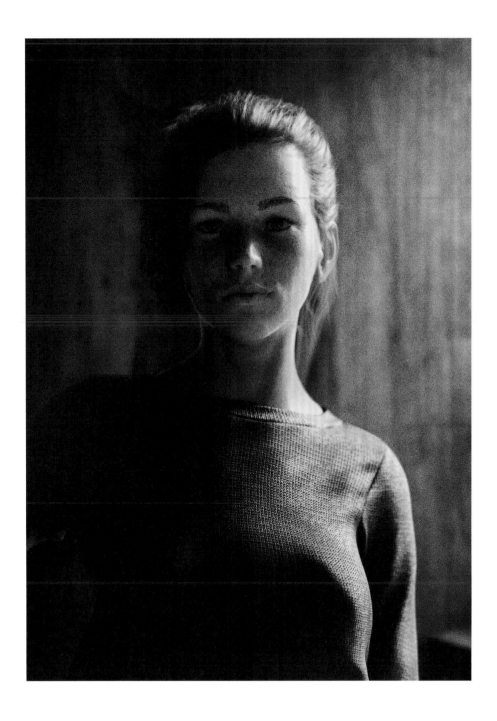

The Book of Veles was published in April 2021 as a documentary project on the production of fake news in Veles, a provincial North Macedonian town which placed itself on the world map in 2016 as an epicenter for fake news production. Six months after the project's publication, Bendiksen revealed that it was a forgery. All the people portrayed are computer-generated 3D models. The backgrounds of the images were made by photographing empty spaces in Veles and then converted into 3D spaces. *The Book of Veles* questions the ease at which fake news can be produced, circulated and believed.

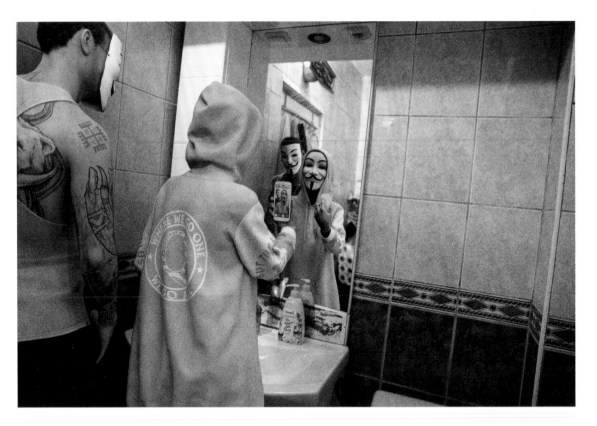

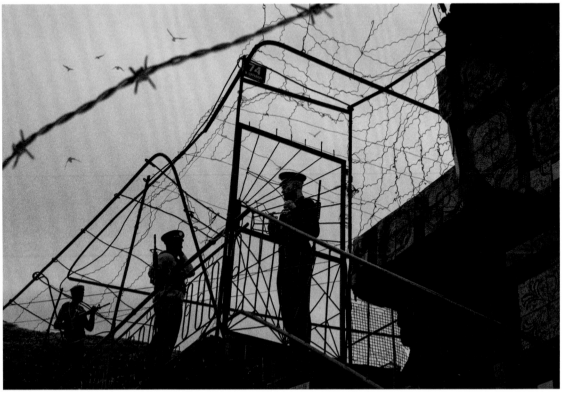

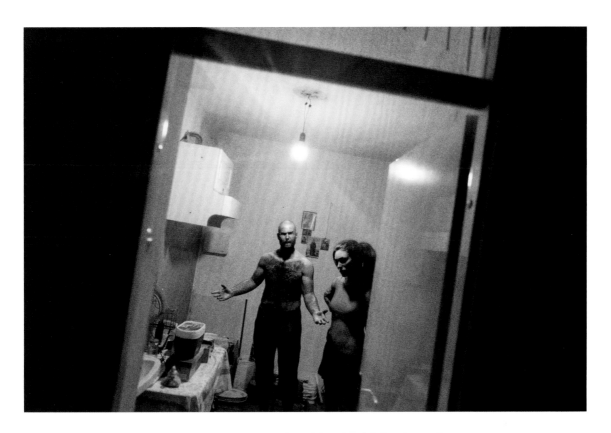

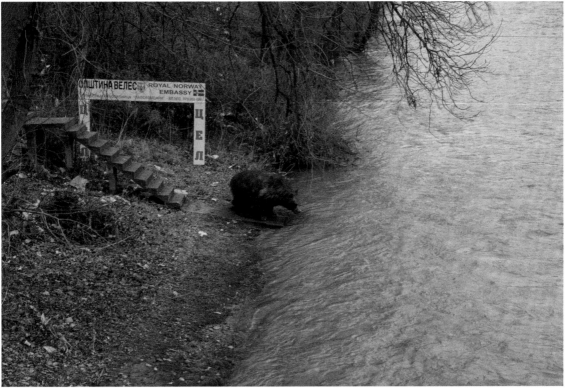

—

red
dresses
along
a
roadside

—

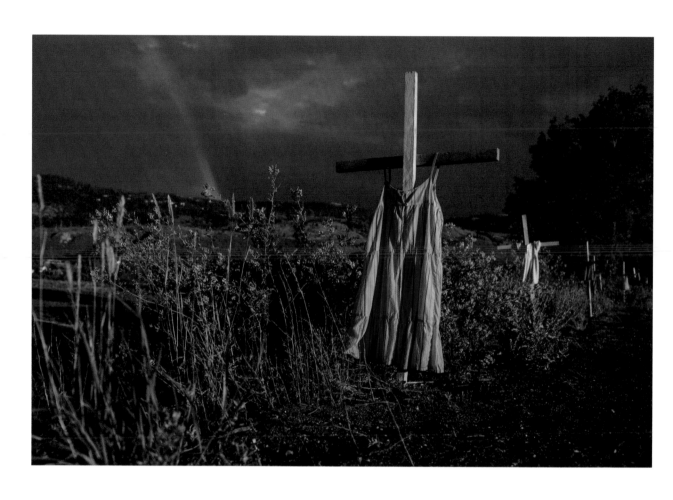

Residential schools began operating in the 19th century as part of a policy of forcibly assimilating people from various Indigenous communities into the Western culture of the European colonists and missionaries. Upwards of 150,000 students were taken away from their homes and parents, often forbidden to communicate in their own languages, and subject to physical and sometimes sexual abuse. A Truth and Reconciliation Commission concluded that at least 4,100 students died while at the schools. The Kamloops school became the largest in the system. In May 2021, a survey using ground-penetrating radar identified as many as 215 potential juvenile burial sites at Kamloops – confirming reports from oral histories.

Red dresses hung on crosses along a roadside commemorate children who died at the Kamloops Indian Residential School, an institution created to assimilate Indigenous children, following the detection of as many as 215 unmarked graves, Kamloops, British Columbia, Canada, 19 June 2021.

—

in
close
proximity

—

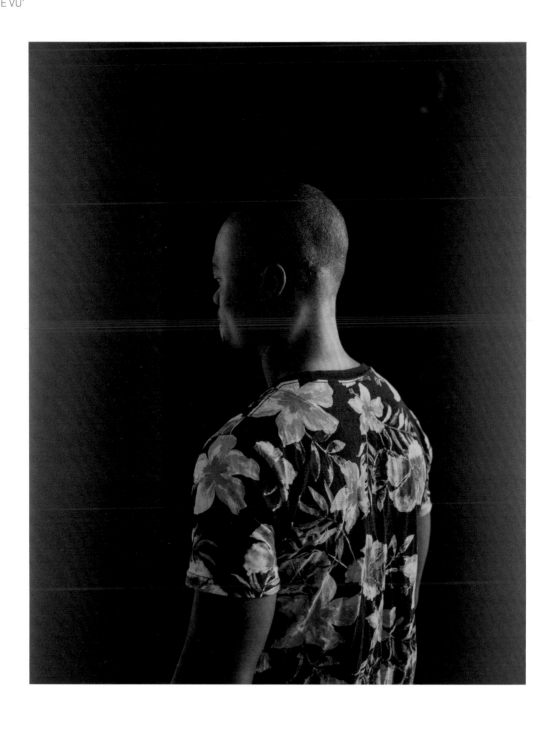

The stories of migrants working in the US meatpacking industry shed light on the lives many migrants lead once they reach their destination. Nationally, immigrants make up 37 percent of the meat industry labor force. During the COVID-19 pandemic, meatpacking plants remained open as they were considered critical infrastructure. The coronavirus spread quickly in an industry where workers operated in close proximity to each other. A study by the US-based Environmental Working Group found that counties with or near meatpacking industries reported twice the national average rate of COVID-19 infection.

An anonymous employee of a Sioux Falls meatpacking plant stands for a portrait at his apartment in Sioux Falls, South Dakota, USA on 6 September 2020. Originally from Eritrea, he moved from a meatpacking plant in Iowa to work in South Dakota. Although he does not like the job, he says he has no other options.

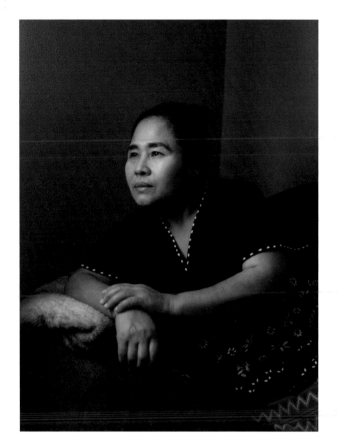

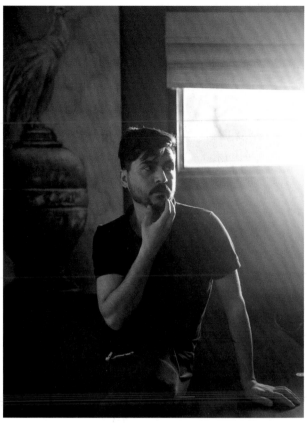

Aye Swaya, a member of the Karen ethnic group, who have experienced persecution from the Myanmar government, is pictured at home in Omaha, Nebraska, USA, on 2 March 2021. She lived in a refugee camp in Thailand, before moving to the US in 2018. At the time of the COVID-19 outbreak she was working in a chicken processing plant in Lincoln, Nebraska, but says she was scared to go to work because so many of her friends became severely ill.

Amjad Farman in Lincoln, Nebraska, USA, on 6 March 2021. Amjad arrived in Lincoln from a refugee camp in Turkey, having fled Iraq to escape the persecution of Yazidi people by the extremist group ISIS. He now works in a chicken processing plant in Lincoln.

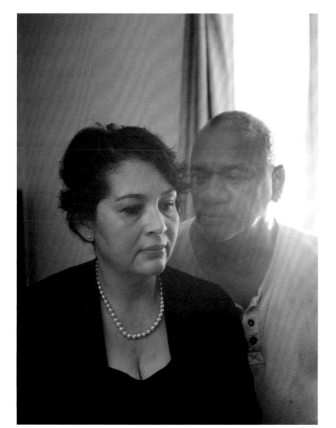

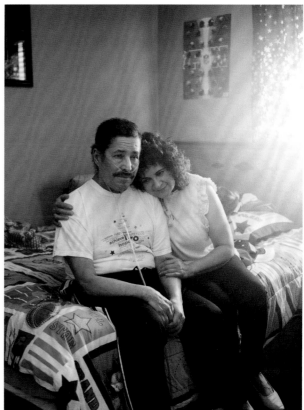

Sandra Sibert sits with her husband, James, in the room where she had to stay in isolation with COVID-19, in Sioux Falls, South Dakota, USA, on 7 September 2020. The couple met while working at a meatpacking plant. Sandra has worked at the plant for 15 years. She fell ill on 7 April 2020, and was sick for three weeks.

José sits in his room with his sister Sara, in Sioux Falls, South Dakota, USA, on 6 September 2020. José worked in a meatpacking plant until contracting COVID-19 in April 2020. He was in the hospital on a ventilator for five months, and still uses an oxygen cylinder. Sara also worked at the factory, but left to become a house cleaner. She took care of her brother during his illness.

—

increasing polarization

—

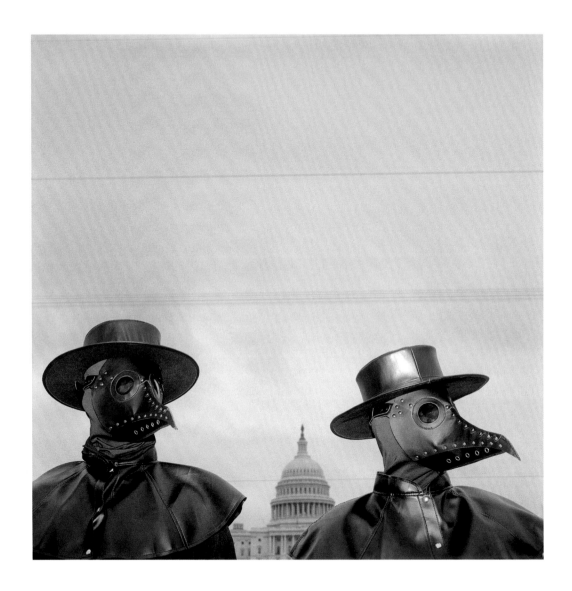

The final year of Donald Trump's presidency of the United States saw increasing polarization in the country, growing social unrest, and disinformation in the media. From early in the run-up to the 2020 US election, President Trump began to falsely accuse Democrat candidates of judicial and electoral subversion. Unrest among his supporters grew into insurrection, culminating in a 6 January attack on the United States Capitol Building in Washington DC. Later in January, Trump was impeached for a second time and charged with incitement to insurrection, later to be acquitted again by the Senate.

Pro-vaccination activists wearing beaked masks, similar to those worn by 17th-century doctors during the plague, seek to draw the attention of spectators around Capitol Hill to promote the message that refusing to be vaccinated will prolong the COVID-19 pandemic, on 25 March 2021.

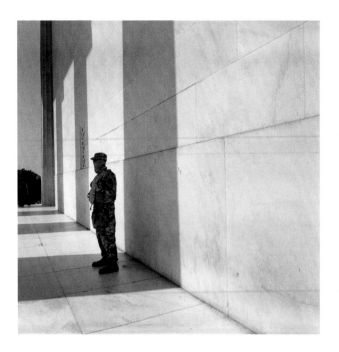

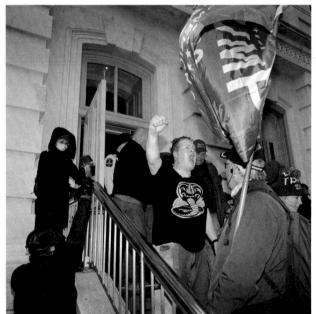

A member of the Washington DC National Guard stands in the shadow of one of the pillars of the Lincoln Memorial, in Washington DC, USA, on 7 June 2020. The White House mobilized the National Guard and numerous federal and local law enforcement officers during growing protests related to the murder of George Floyd.

A statue of Confederate general Albert Pike lies with a noose around its neck, after protesters pulled it down and set it on fire, in Judiciary Square, Washington DC, USA, on 19 June 2020. It was one of many Confederate monuments torn down around the country to protest racism on Juneteenth, the day commemorating the emancipation of enslaved people.

Protesters stream toward the Capitol from the West Front Lawn, as the building is breached by rioters breaking through windows and doors, to contest Joe Biden's electoral victory, in Washington DC, USA, on 6 January 2021. The Justice Department estimated between 2,000 and 2,500 people invaded the Capitol.

A Trump supporter pumps his fist as he is ejected from the Capitol Building, after it had been breached by rioters in an attempt to stop the certification of the 2020 presidential election, Washington DC, USA, 6 January 2021.

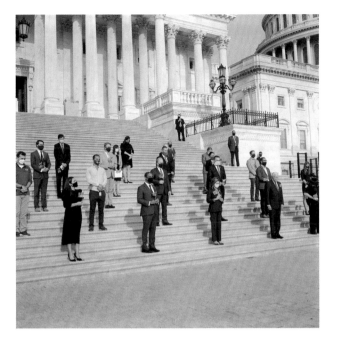

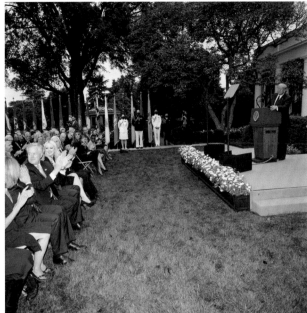

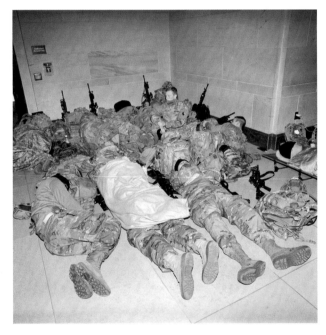

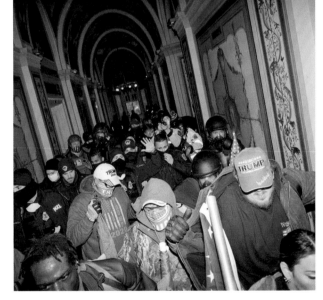

Speaker Nancy Pelosi, House Majority Leader Steny Hoyer, together with other Democrat representatives and aides participate in a ceremony on the steps of the Capitol, in Washington DC, USA, on 11 September 2020, to commemorate the 9/11 terrorist attacks.

President Donald Trump announces Judge Amy Coney Barrett's nomination to the Supreme Court, at the White House, Washington DC, USA, on 26 September 2020. President Trump and first lady Melania both tested positive for COVID-19 shortly after the ceremony.

National Guard soldiers rest inside the Capitol Building, Washington DC, USA, on 7 January 2021. The troops were called on following the 6 January invasion of the Capitol Building to protect lawmakers and the complex from further attack, and remained deployed until 24 May.

Pro-Trump supporters invade a Capitol hallway, after the building had been breached during a protest to overturn Joe Biden's electoral victory, in Washington DC, USA, on 6 January 2021.

—
scratches
and
pinpricks
—

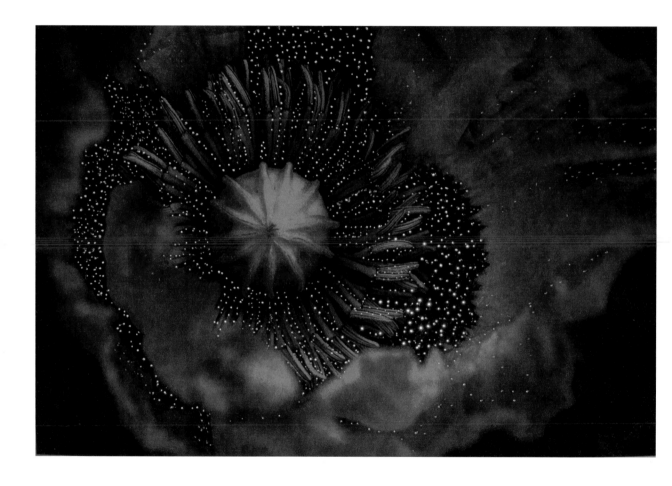

Mexico is the third-largest opium producer in the world, with half of the production being grown in its second-poorest state, Guerrero. The drug economy has transformed the social structure of the largely Indigenous farming communities who have turned to poppy cultivation as a means of survival. The photographer put scratches and pinpricks into prints of the photographs to represent trauma and the scratching of the poppy flower during opium extraction, while the color red represents drug violence and blood, but also life.

A poppy flower in Acatepec, Guerrero, Mexico, on 13 December 2020. Extracted opium gum from the poppy is turned into heroin in Mexico before being transported to the US and Canada.

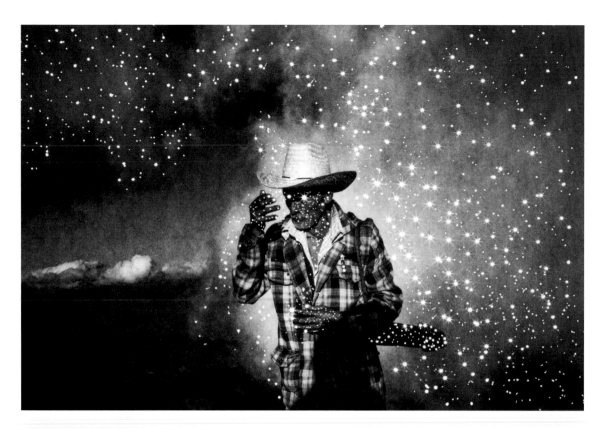

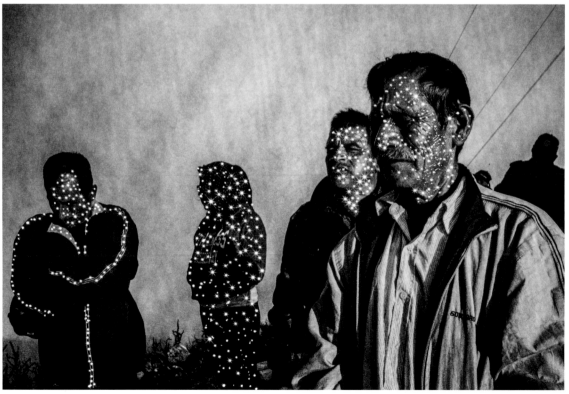

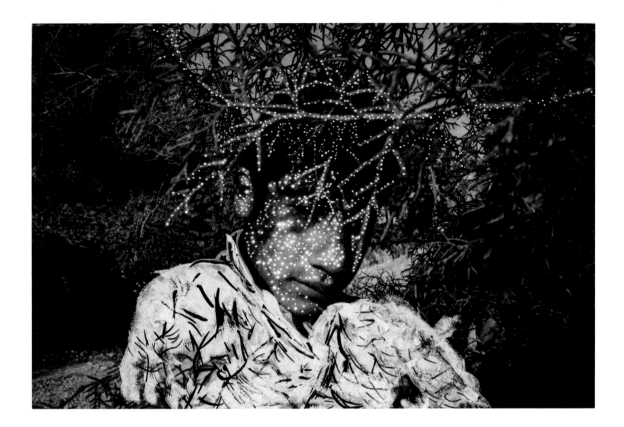

A Mixtec elder on Cerro de la Garza, Guerrero, Mexico, on 31 December 2021. Every year, on 31 December, Mixtecs climb the hill to perform rituals commemorating the end and beginning of a life cycle.

A young man in Malinaltepec, Guerrero, Mexico, on 10 February 2021. He lives in a poppy-growing community.

The Mixtec community celebrates a ritual that commemorates the end and beginning of a life cycle, at a sacred hill in Guerrero, Mexico, on 31 December 2021. These sacred hills are surrounded by poppy fields. An increasing amount of drug violence has led to communities arming themselves to defend their territories, with children also joining these efforts.

—

temporary shelter

—

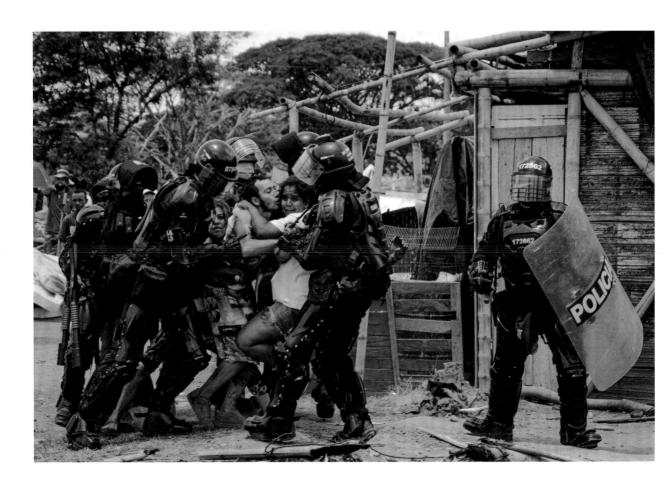

Evictions of residents of the San Isidro settlement began on 3 March 2021, ahead of construction of a railroad planned to connect the capital of the Risaralda district with Buenaventura, Colombia's main Pacific seaport. Authorities said the railroad megaproject would bring work and investment to the area, and that the ground did not officially belong to the people being evicted. Following the publication of Encina's photographs and subsequent media coverage, members of the central government intervened and the evicted residents from San Isidro were promised rehousing and compensation. They were resettled in temporary shelter, but by early 2022 had still not been relocated to new land.

Police agents arrest a man while his wife and family resist, during evictions of people from the San Isidro settlement, in Puerto Caldas, Risaralda, Colombia, on 6 March 2021.

—

most
precious
treasure

—

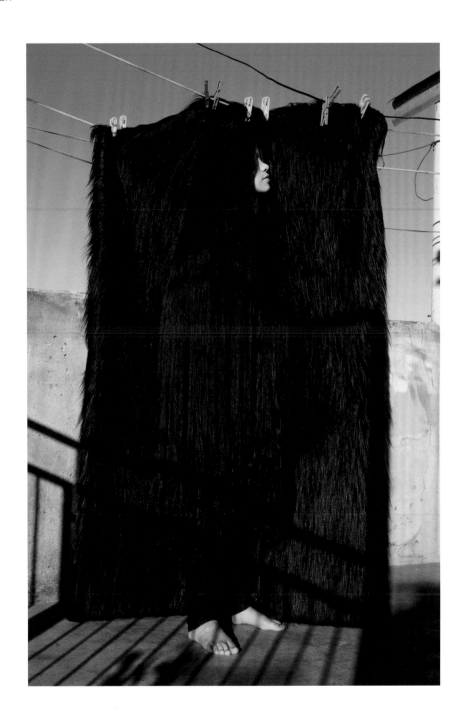

In August 2020, Antonella (12), who lives in Buenos Aires, Argentina, vowed to cut her long hair only when she could resume in-person classes at school, which had been suspended as a result of the COVID-19 pandemic. Antonella said she was offering up her most precious treasure in exchange for getting her school life back. Her hair was her identity. She said: "When I finally go back to school they will know I'm a different person, I feel like a different person." She cut her hair on 25 September 2021, on the weekend before she returned to classes.

Antonella stands in front of a fake fur blanket, on the rooftop terrace at her family's home in Buenos Aires, Argentina, on 25 May 2021. She goes up to the terrace to wash clothes and enjoy the sun every day. The disruption to routines, education, recreation, as well as concern for family income and health is leaving Antonella feeling afraid, anxious and worried about her future.

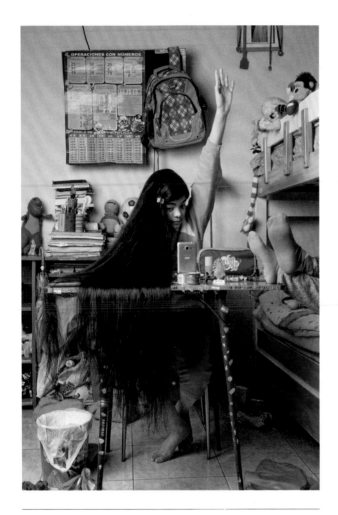

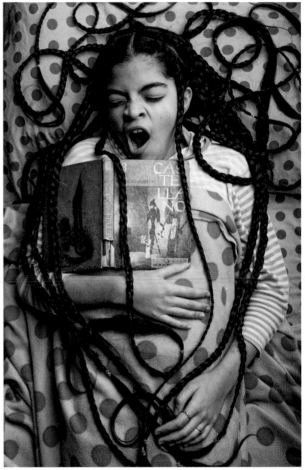

Antonella studies via Zoom, using her mother's mobile phone, in her room at home in Buenos Aires, Argentina, on 13 June 2021. Her parents are keen that she keeps up-to-date with her education, and, along with other parents, organize group studies and virtual get-togethers via WhatsApp.

Antonella yawns while studying in bed, in her room at home in Buenos Aires, Argentina, on 29 July 2021. She says she feels a lack of motivation studying at home, and often studies in bed as she doesn't feel like getting up.

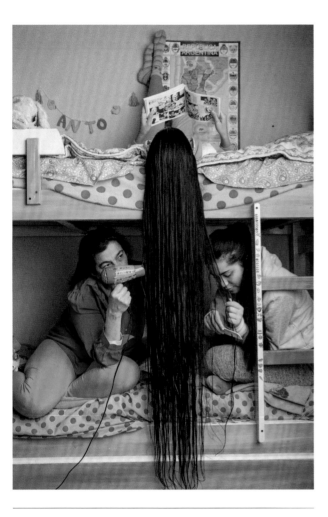

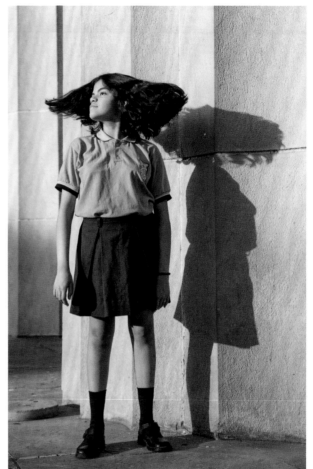

Antonella's mother Felicitas and her sister Carolina dry, comb and rub her hair with rosemary oil, at home in Buenos Aires, Argentina, on 23 July 2021. Numerous academic studies highlight the importance of strong parental support in creating positive attitudes towards education among children working at home.

Antonella swings her newly cut hair outside the Faculty of Engineering at the University of Buenos Aires, Argentina, on 20 November 2021, after returning to school having missed 260 days of in-person classes due to the COVID-19 pandemic. She wanted to have her portrait taken there because her ambition is to study engineering after finishing school.

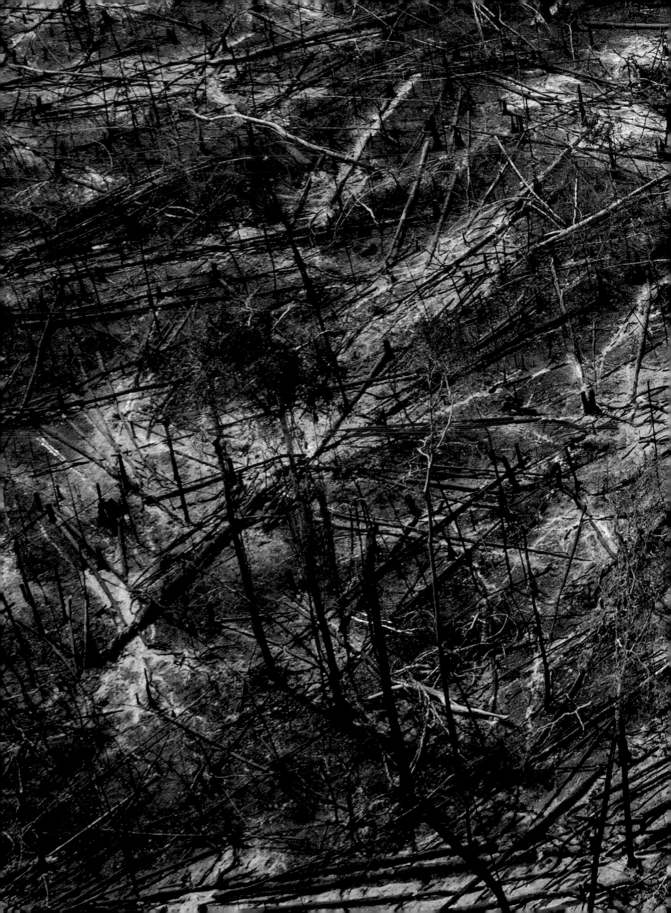

—

environmentally regressive policies

—

The Amazon rainforest is under great threat, as deforestation, mining, infrastructural development and exploitation of natural resources gain momentum under President Jair Bolsonaro's environmentally regressive policies. Since 2019, devastation of the Brazilian Amazon has been running at its fastest pace in a decade. Exploitation of the Amazon not only has devastating effects on the Amazon's ecosystem, which is extraordinarily biodiverse, it also has a number of social impacts, particularly on Indigenous communities who are forced to deal with significant degradation of their environment, as well as their way of life.

Members of the Munduruku community line up to board a plane to present their demands against the Belo Monte Dam to the government, at Altamira Airport, in Pará, Brazil, on 14 June 2013.

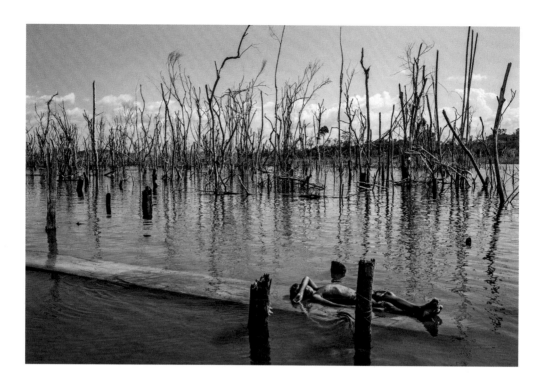

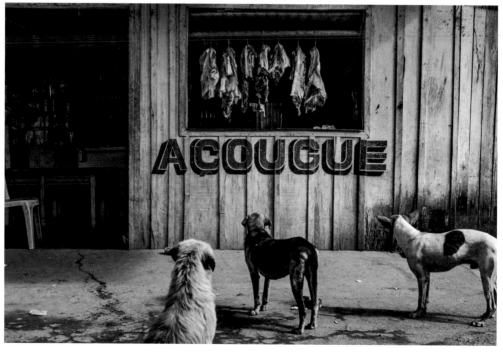

A boy rests on a dead tree trunk in the Xingu River in Paratizão, a community located near the Belo Monte hydroelectric dam, Pará, Brazil, on 28 August 2018. He is surrounded by patches of dead trees, formed after the flooding of the reservoir.

Stray dogs stare at meat hanging in a butcher's shop in Vila da Ressaca, an area previously mined for gold but now almost completely abandoned, in Altamira, Pará, Brazil, on 2 September 2013.

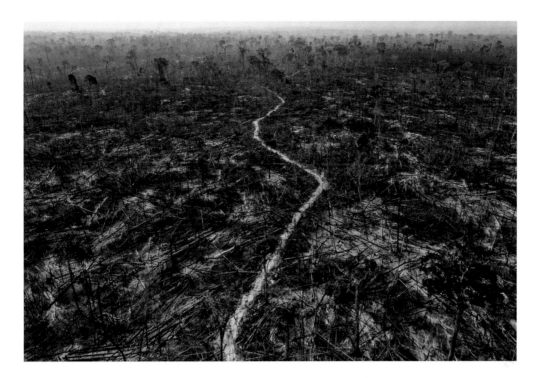

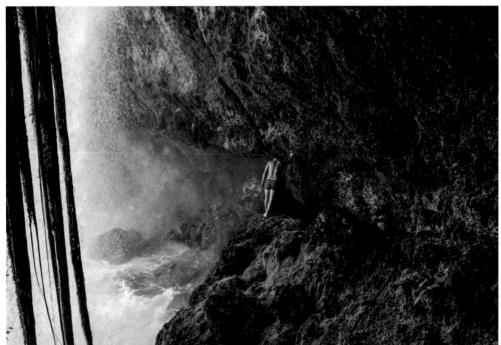

Massive deforestation is evident in Apuí, a municipality along the Trans-Amazonian Highway, southern Amazon, Brazil, on 24 August 2020. Apuí is one of the region's most deforested municipalities.

Mailon Araxi, a young member of the Manoki Indigenous community, many of whom have turned to work in large commercial soybean farms for income, crosses the Cravari River under a waterfall in the Irántxe Indigenous Land, in Mato Grosso, Brazil, on 25 August 2021.

–

forgotten memories of the land

–

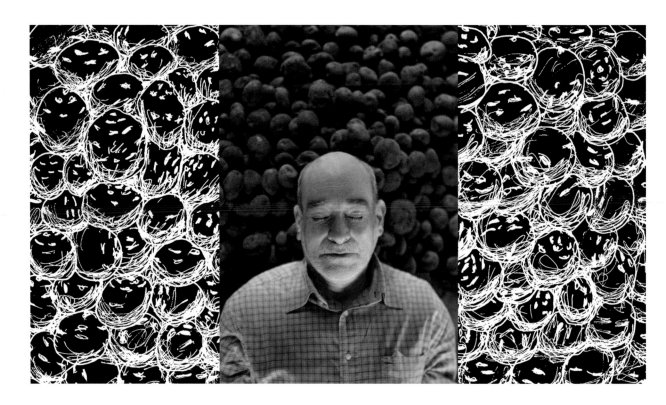

Blood is a Seed (*La Sangre Es Una Semilla*) questions the disappearance of seeds, forced migration, colonization, and the subsequent loss of ancestral knowledge. The video is composed of digital and film photographs, some of which were taken on expired 35mm film and later drawn on by Romero's father. In a journey to their ancestral village of Une, Cundinamarca, Colombia, Romero explores forgotten memories of the land and crops and learns about her grandfather and great-grandmother, who were 'seed guardians' and cultivated several potato varieties, only two of which still commonly exist.

Scan the QR code
to watch the video.

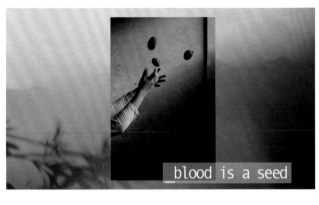

blood is a seed

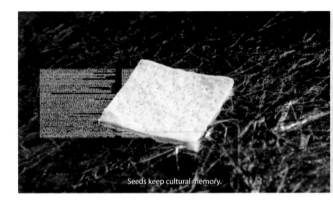

Seeds keep cultural memory.

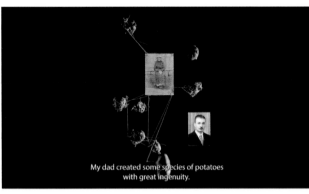

My dad created some species of potatoes
with great ingenuity.

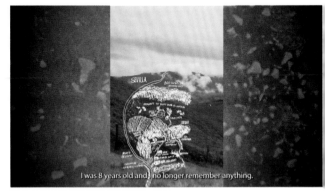

I was 8 years old and I no longer remember anything.

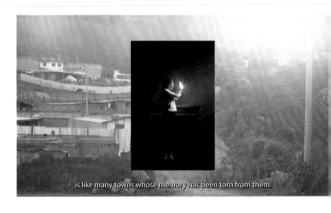

is like many towns whose memory has been torn from them.

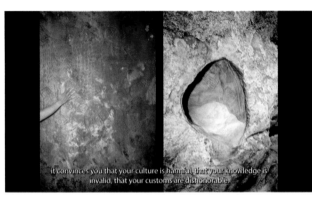

it convinces you that your culture is harmful, that your knowledge is
invalid, that your customs are dishonorable.

Telling stories is the first form of resistance
to the great blots of the world.

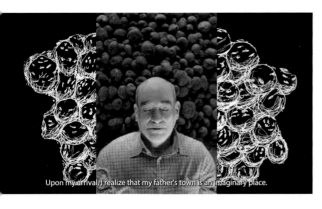

Upon my arrival, I realize that my father's town is an imaginary place.

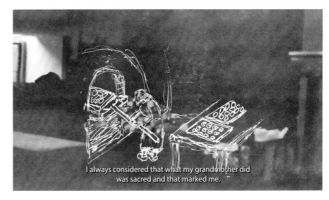

I always considered that what my grandmother did was sacred and that marked me.

which were the Tocana, the Criolla, the Pastusa, the Sabanera...

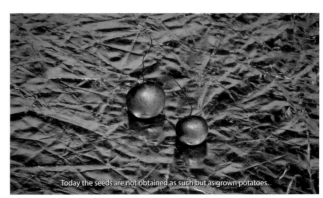

Today the seeds are not obtained as such but as grown potatoes.

Colonization is a monster that devastates everything:

this narrated potato is a tribute to suspended memory and to the various forms of resistance.

—

homemade
weapons

—

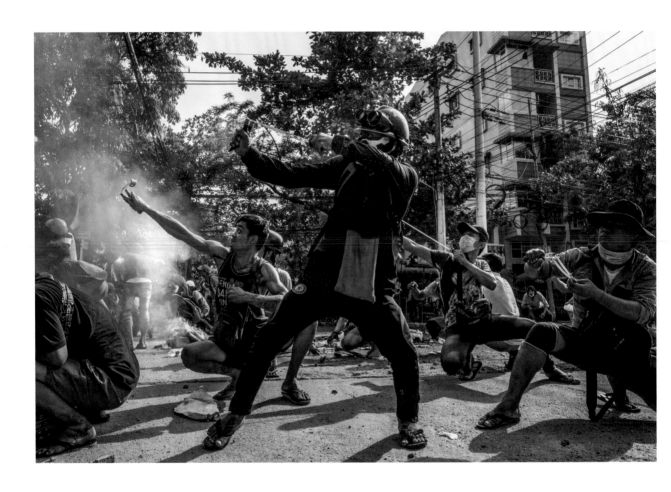

On 1 February 2021, military leaders staged a coup in Myanmar, hours before a newly elected parliament was to have been sworn in. Huge protests erupted nationwide, and were met with a harsh military crackdown. International media organizations and a UN official reported that the military were firing live ammunition at civilian protesters and into people's homes. The photographer remains anonymous for reasons of personal safety. The day before this photograph was taken saw 114 civilians reported killed.

Protesters use slingshots and other homemade weapons in a clash with security forces in Yangon, Myanmar, on 28 March 2021.

—

cool
burns

—

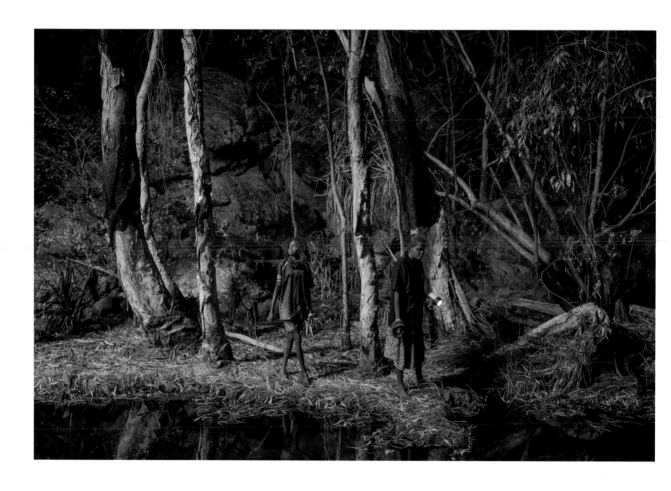

Indigenous Australians strategically burn land in a practice known as cool burning, in which fires move slowly, burn only the undergrowth, and remove the build-up of fuel that feeds bigger blazes. The Nawarddeken people of West Arnhem Land, Australia, have been practicing controlled cool burns for tens of thousands of years and see fire as a tool to manage their 1.39 million hectare homeland. Warddeken rangers combine traditional knowledge with contemporary technologies to prevent wildfires, thereby decreasing climate-heating CO_2.

Stacey Lee (11, left) sets the bark of trees alight to produce a natural light source to help hunt for file snakes (*Acrochordus arafurae*), in Djulkar, Arnhem Land, Australia, on 22 July 2021.

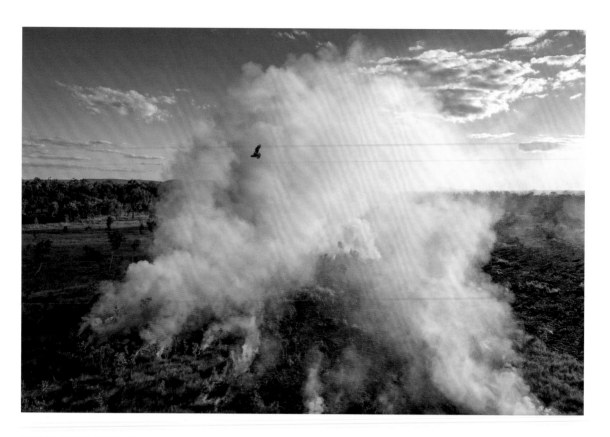

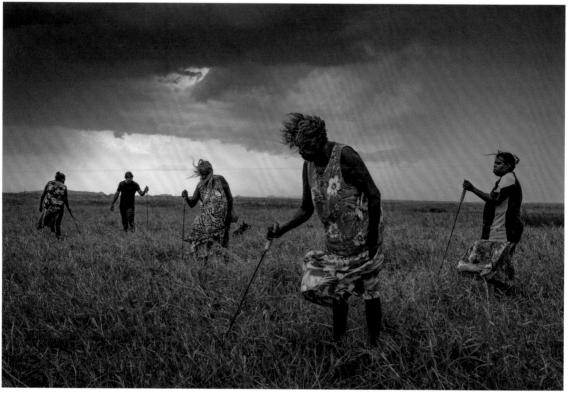

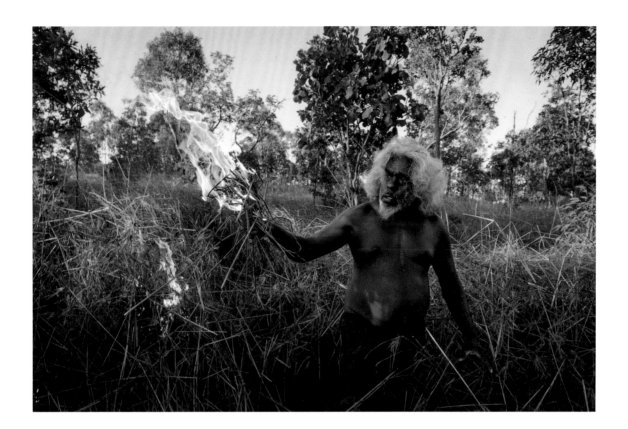

A black kite (subspecies *Affinis* of *Milvus migrans*) flies above a cool-burn fire lit by hunters earlier in the day, in Mamadawerre, Arnhem Land, Australia, on 2 May 2021. The raptor, also known as a firehawk, is native to northern and eastern Australia, and hunts near active fires, snatching up large insects, small mammals, and reptiles as they flee the flames.

Nawarddeken elder Conrad Maralngurra burns grass to protect the Mamadawerre community from late-season 'wildfires', in Mamadawerre, Arnhem Land, Australia, on 3 May 2021. The late-evening fire will die out naturally once the temperature drops and moisture levels rise.

A group of Nawarddeken elders hunt for turtles with home-made tools on floodplains near Gunbalanya, Arnhem Land, Australia on 31 October 2021. The group of women spent all day finding just two turtles, which are a popular delicacy. Soon the grass will be burned to make the hunt easier.

—

fine
particulate
matter

—

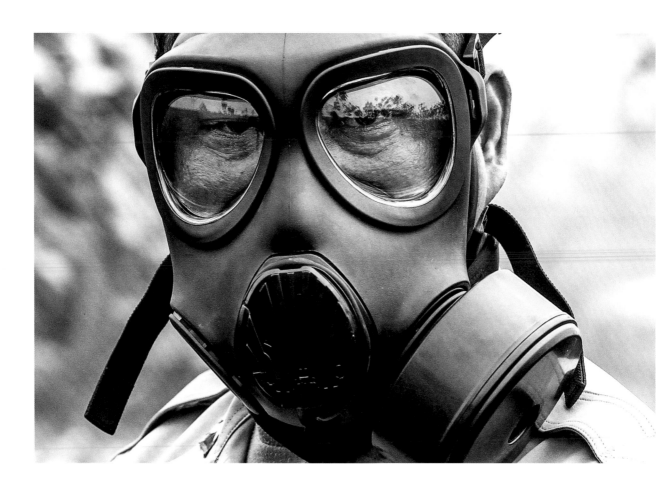

Indonesia has seen exceptionally large wildfires in recent years. Haze created by fire can affect human health, especially as it carries fine particulate matter, which can penetrate deep into the lungs. Dry conditions make it easier for fires to be set to clear land for agriculture, but also more likely that they spread out of control. Indonesia is the world's largest producer of palm oil and industrial-scale land clearance has increased the risk of wildfire immensely. The country has lost around a quarter of its forest area since the beginning of data collection in 1990.

A police officer wears a gas mask as protection against smoke from a peatland fire in Ogan Komering Ilir, South Sumatra, Indonesia, on 11 September 2015.

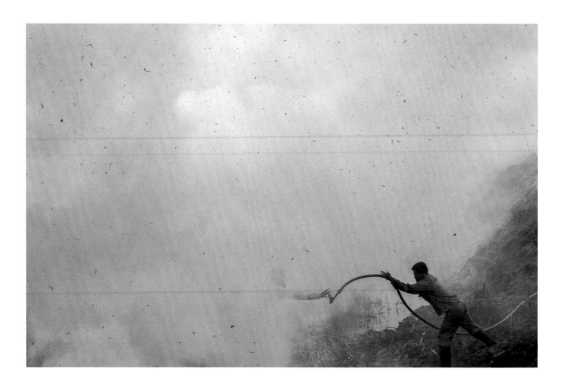

A firefighter throws another a hose, while attempting to extinguish a fire in Ogan Ilir, South Sumatra, Indonesia, on 5 September 2015.

Ria Susanti examines an X-ray of her daughter Fadhila Rahma's lungs, in Palembang, South Sumatra, Indonesia, on 3 November 2015. Fadhila died from an acute respiratory infection thought to have been caused by exposure to smog from forest and land fires.

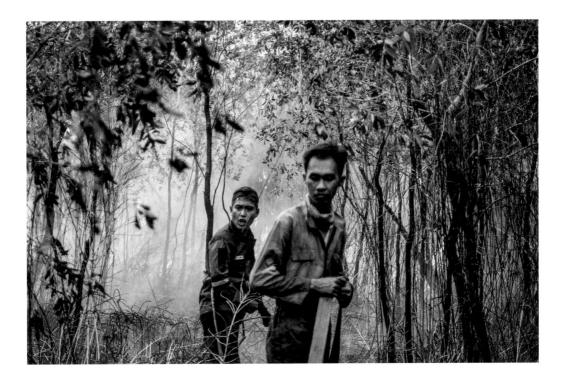

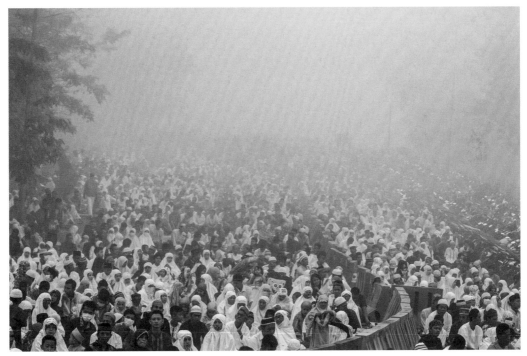

A firefighter shouts to a colleague for water to extinguish a peat fire in Arisan Jaya, South Sumatra, Indonesia, on 31 July 2021. Burning peatlands are difficult to extinguish, and in the dry season water is difficult to obtain.

People gather during the Muslim festival of Eid al-Adha in Palembang, Indonesia, on 24 September 2015. Smog from forest fires had pushed air quality to unhealthy levels, prompting the cancellation of flights and warnings for people to stay indoors.

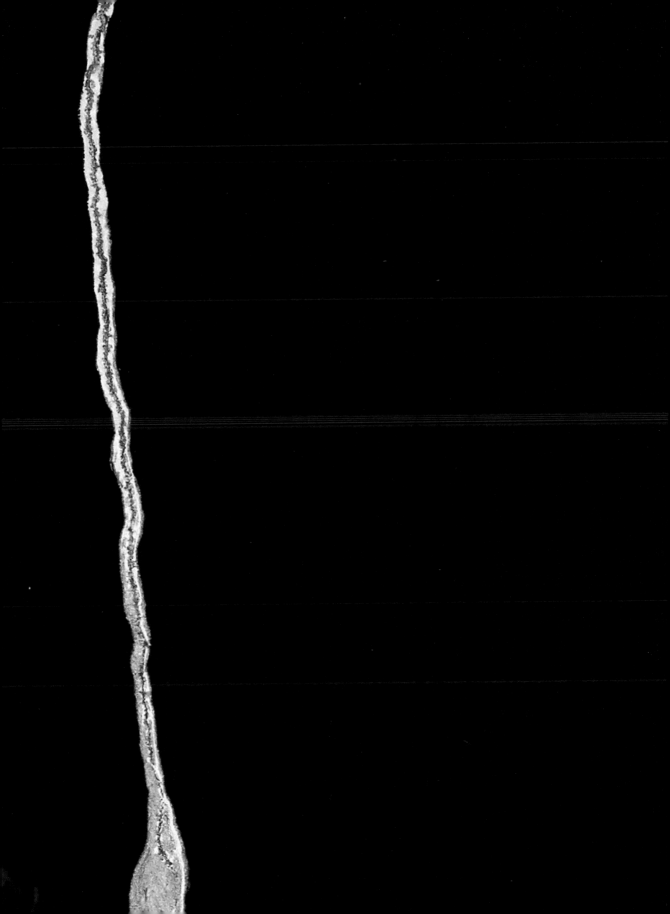

—

hope
for
a
better
future

—

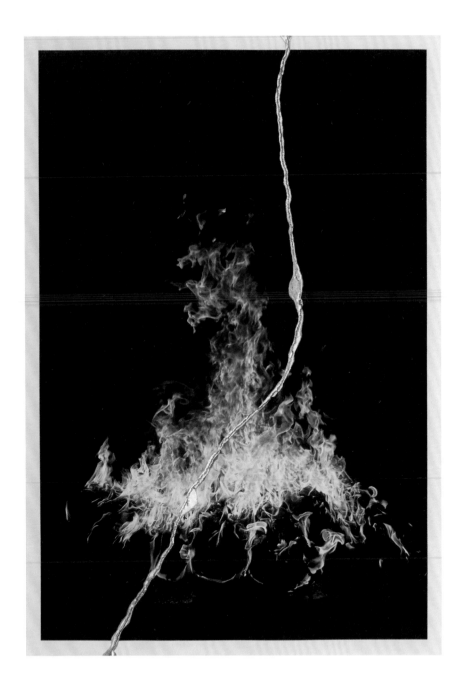

The Will to Remember juxtaposes archival images of the 6 October 1976 massacre of students at Bangkok's Thammasat University with photographs Rachurutchata took during the 2020-2022 Thai protests, in order to understand the root causes of the present-day protests. The photographer emulates the Japanese art of *kintsugi* by tearing photographs, then mending them with lacquer and powdered gold. Rachurutchata uses the *kintsugi* to symbolize the transformation of trauma into hope for a better future.

Youth-led protesters burn mock corpses in the soccer field where students were killed during the 6 October 1976 massacre, on the 45th anniversary of the event at Thammasat University, Bangkok, Thailand, on 6 October 2021.

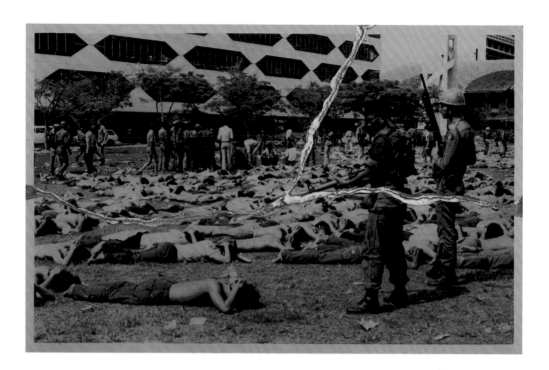

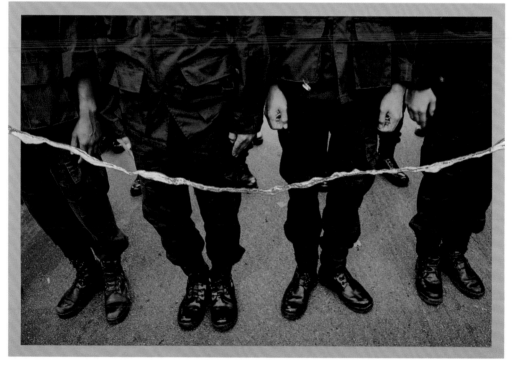

Archive image of the 6 October 1976 massacre in Bangkok, Thailand. Thongchai Winichakul, the student leader at the time of the massacre, reports that he saw people lying on the ground, not realizing that some of them were dead.

Legs of policemen during a protest in Bangkok, Thailand, on 6 October 2020. According to the photographer, the golden scars on the images represent resilience against the suppression of knowledge, and the possibility of a more beautiful future.

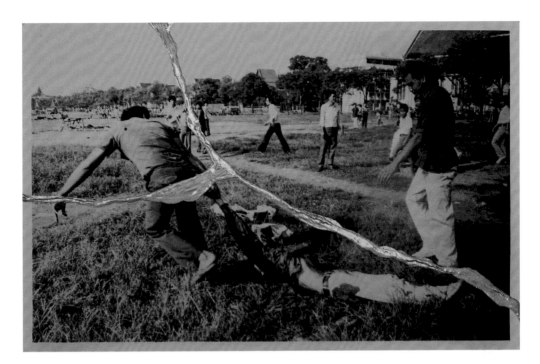

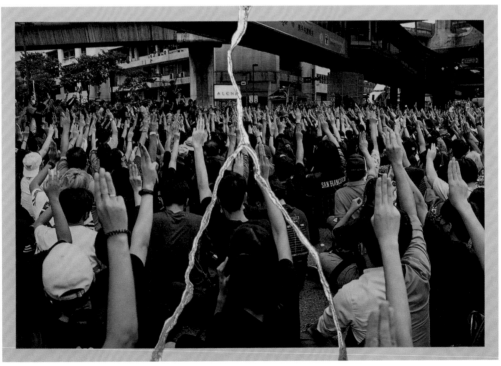

Archive image of the 6 October 1976 massacre in Bangkok, Thailand.

Protesters make a three-finger salute – popularized by the *Hunger Games* films – in Bangkok, Thailand, on 15 October 2020. Pop cultural symbols have become an important vehicle for protest.

AMBER BRACKEN
FOR THE NEW YORK TIMES

KAMLOOPS
RESIDENTIAL SCHOOL

PHOTO
OF THE YEAR

188

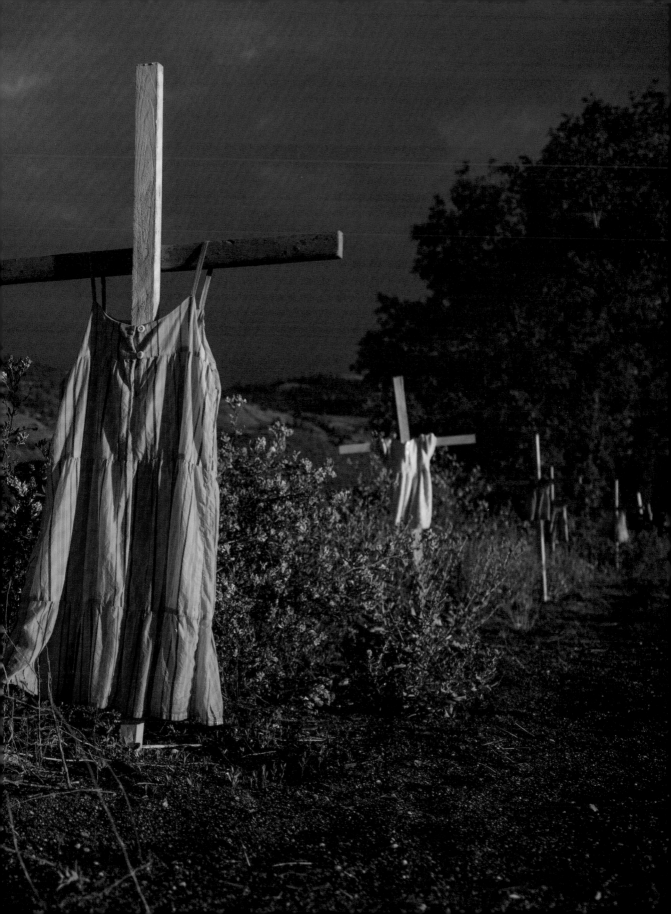

SAVING FORESTS
WITH FIRE

STORTY
OF THE YEAR

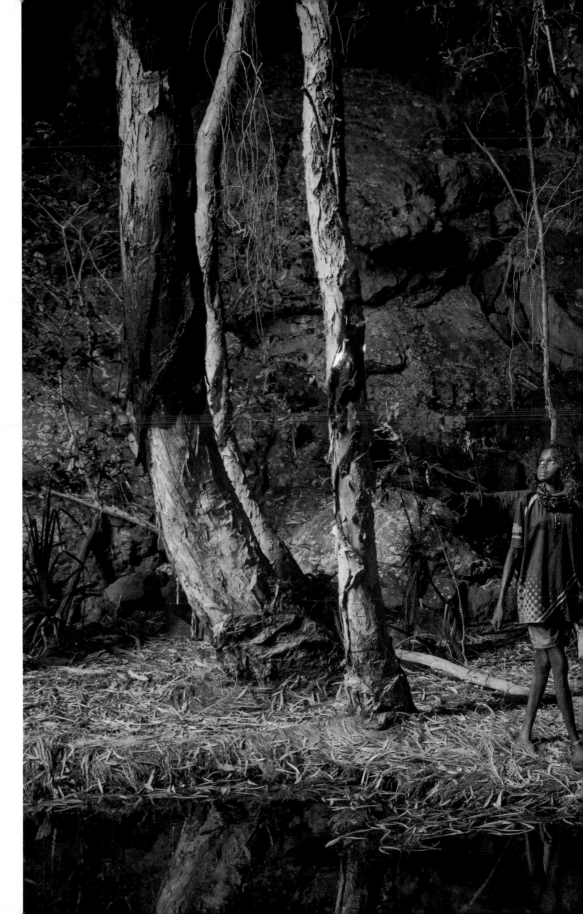

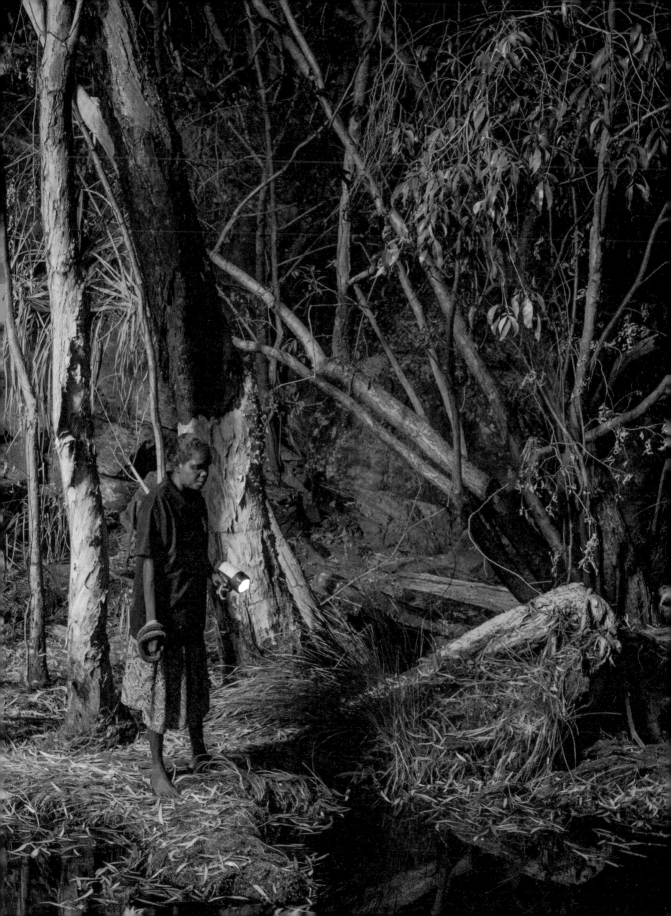

LONG-TERM PROJECT
AWARD

**AMAZONIAN
DYSTOPIA**

LALO DE ALMEIDA
FOR FOLHA DE SÃO PAULO/
PANOS PICTURES

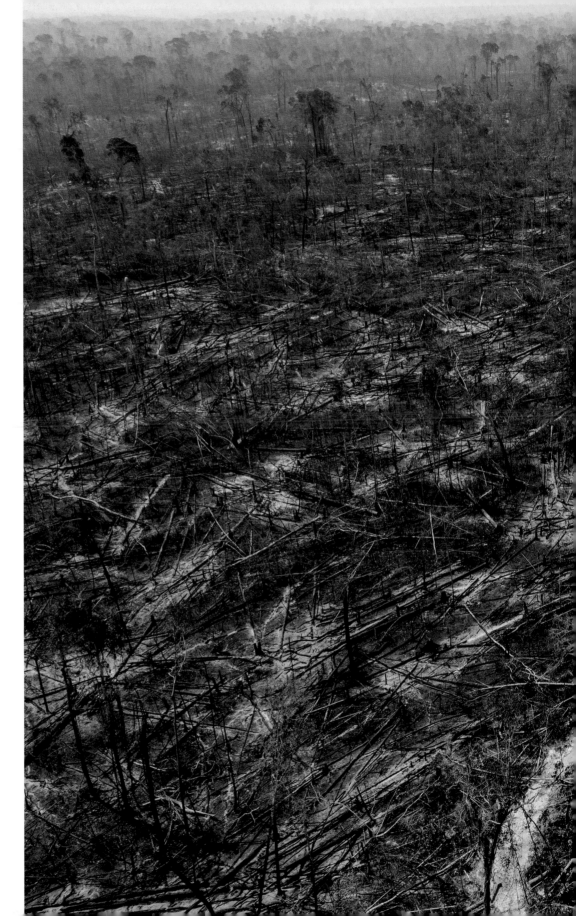

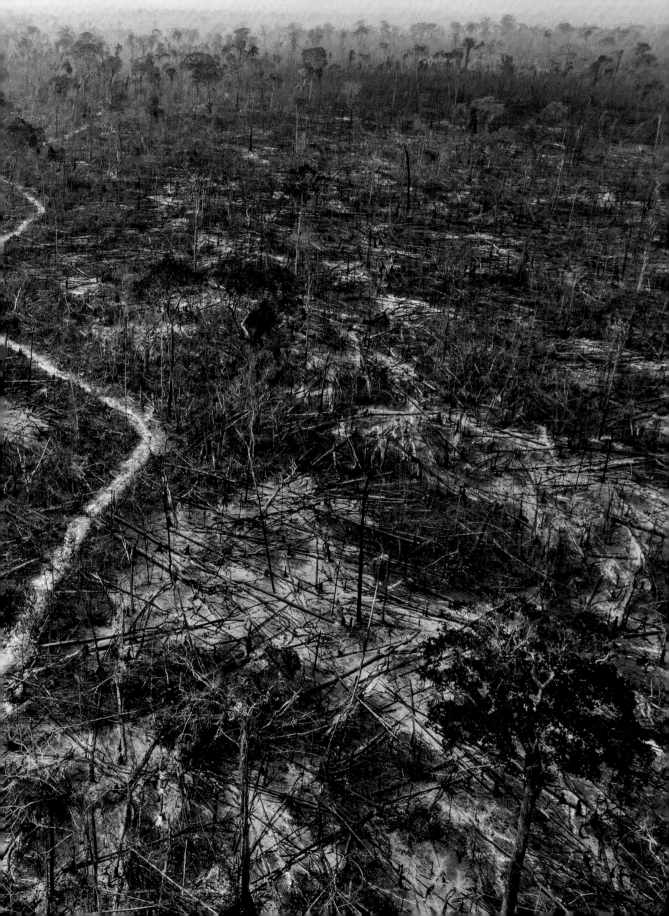

OPEN FORMAT
AWARD

**BLOOD
IS A SEED** ISADORA
ROMERO

—
Deeper insight,
more understanding
—

Joumana El Zein Khoury
Executive Director, World Press Photo Foundation

When we finalized our new strategy in the summer of 2021, we knew that it was the only way forward for World Press Photo. Our strategy has at its core the importance of awarding and sharing stories from all over the world in a representative, balanced and context-sensitive manner. That belief was based on our brainstorms, expertise, experience, on the lessons we learned, on listening, and advice from many stakeholders, yet we knew that it was 'theoretical' until the moment of its actual implementation.

The first big moment of truth in this respect was the 2022 Photo Contest, which brought tens of thousands of entries, and then juries, jury deliberations, and winners. As executive director of World Press Photo, it was exhilarating to see how the new way of working we had arrived at in theory was producing the changes that we were hoping for.

Seeing the manner in which the regional juries were able to read the photos and understand the stories, and the sensitivities and complexities of the multiple layers of context they brought to discussions, was a privilege in itself. It was fascinating to listen in on discussions among

the global jury members as they explained why certain stories, such as a flood in Europe, for example, were exceptional in one region while considered normal in another; or why it is important to understand the different aesthetics, threats, challenges, urgencies and stereotypes that need to be confronted, or which voices need to be heard. These insights into the juries' considerations offer us an understanding of the particular challenges and opportunities that each region is facing. That is why we asked the regional and global chairs to write a few of their reflections for this Yearbook.

This year was yet again a difficult and dangerous year for many photo-journalists. Photographers are increasingly at risk and press freedom is under attack in many parts of the world, from Sudan to Myanmar. The experience of this 2022 World Press Photo Yearbook would not be nearly as rich without the bravery and talent of individuals such as those who took the winning photos. We especially want to celebrate the people who captured the moments that tell us so many significant stories of the past year. Their work has not only made this book possible, it has contributed to a better understanding of our world.

Photographs are a complex experience. They take in a scene, an event, a moment, seen by the photographer and recorded by a camera, then re-experienced by each individual viewer. But images in the news, particularly on social media, are quickly erased by new events and replaced by new images, giving us little time to think in any depth about what is being portrayed.

A book is different. It sits on a table or a bookshelf and asks to be opened. This Yearbook is an in-depth look into photojournalism and documentary photography from all over the world, offering you a different experience that in some way reflects our changing organization. It calls for reflec-tion, for thinking about the bigger picture, asking questions, making connections and observing changes. We hope that this Yearbook will draw you back many times and each time inspire you to look anew.

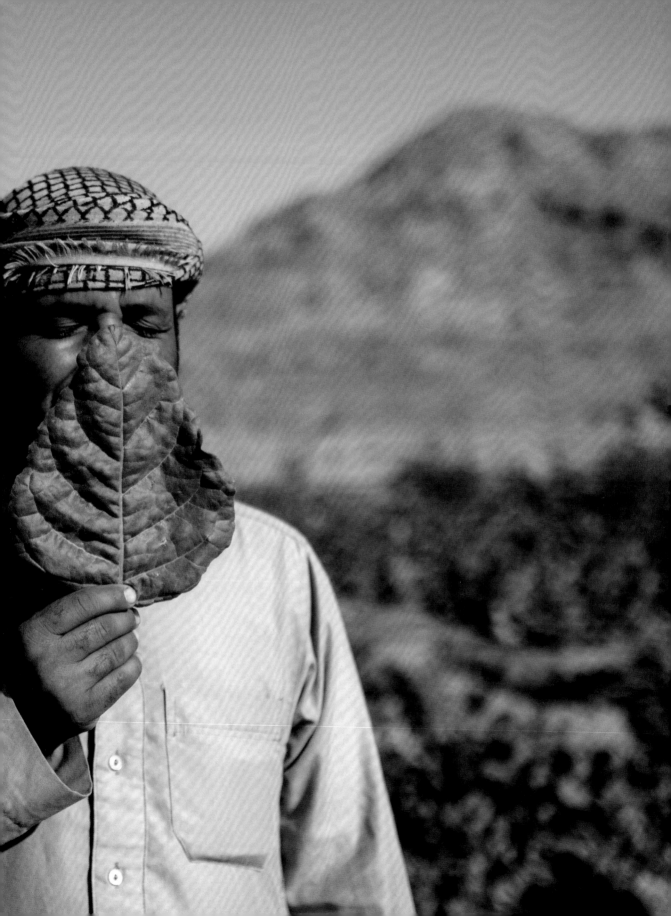

Africa

N'Goné Fall
Chair of the Jury for Africa

What did photographers witness in a territory of 30 million square kilometers in 2021? Protests in the streets of Algeria, Burkina Faso, Cameroon, Libya, Nigeria, Senegal, South Africa, Sudan, Tunisia and Uganda; failed coups in the Central African Republic and Niger; the overturn of governments in Chad, Guinea, Mali and Sudan; war in Ethiopia; volcanic eruption in DRC; flooding in South Sudan; drought in Kenya; famine in Madagascar; the proliferation of forced evictions to pave the way for mining projects; galloping water scarcity. If the African continent once again faced challenging times, photographers on the ground revealed a more nuanced situation, through images capturing disillusionment as well as bravery and hope.

There are ongoing stories that we must by no means forget, as it is our responsibility, collectively, to keep them alive and to urge people never to turn away from the bad and the ugly for the sake of preserving a personal comfort zone. We owe it to those who are giving their lives fighting for fundamental rights, who are not just dreaming of a better world, but who struggle tirelessly to make it happen.

There are stories making headlines that will promptly be erased by other breaking news, as if chaos, trauma and pain were competing to

gain exclusive global empathy. Yet African youth and civil society
are not in a transnational competition for the world's attention. They
are simply demanding the irrevocable implementation of equal justice
and social change, locally, with or without the assistance of the inter-
national community.

There are refreshing stories you may never hear about, which un-
veiled the panache and extravagance of some African societies,
while warmly praising their sense of solidarity. Community-building
remains a cherished everyday gesture transmitted, over time, by
generations of Africans. And we must celebrate that.

While the members of the jury for Africa – hailing from Algeria, Nigeria,
Senegal, South Africa and Sudan – were paying a particular attention
to invigorating stories, the disruption of our regional jury meetings by
a coup and a police interrogation brought us back to damning realities
that we could not deny. Conversations, punctuated by moments of
silence, filled our sessions. Silences because, as Africans, we did not
need to state the obvious, but always took time to pay tribute to what
photographers had to say about a land, too often overlooked, that
has so many experiences to learn from.

Winners

—

FAIZ ABUBAKR MOHAMED

SINGLES

FAIZ ABUBAKR MOHAMED
SUDAN

—

Faiz Abubakr Mohamed is a photographer based in Khartoum, Sudan. His work has been exhibited internationally and published in *The New York Times*.

—

@faizabubak

SOPHIYAH SULAIMON ADELAKUN

STORIES

SODIQ ADELAKUN ADEKOLA
NIGERIA

—

Sodiq Adelakun Adekola is a photo and video journalist currently based in Abuja, Nigeria. His work centers around human rights abuse, social exclusion, news and documentary stories, with a particular focus on the rights of women and children.

—

@sodiqadelakun

Jury

—

F. DIOUF PHOTOGRAPHY

N'GONÉ FALL / CHAIR
SENEGAL

—

N'Goné Fall is an independent curator in cultural policies as well as the author of strategic plans and evaluation reports for national and international institutions.

—

independent.academia.edu/NGonéFall

SARAH HIEBA

ALA KHEIR
SUDAN

—

Ala Kheir is a photographer, co-founder of the Sudanese Photographers Group, and founder of The Other Vision (TOV), a photography platform in Sudan.

—

alakheir.com | @ala.kheir

PIERROT MEN

REHAB ELDALIL

LONG-TERM PROJECTS

RIJASOLO
MADAGASCAR/FRANCE

—

Rijasolo is a photojournalist and photographer whose work focuses on reportage and corporate projects. He is based in Antananarivo, Madagascar and works as a photographer for Agence France-Presse.

—

rijasolo.com | @rijasolo

OPEN FORMAT

REHAB ELDALIL
EGYPT

—

Rehab Eldalil is a documentary photographer and visual storyteller based in Cairo, Egypt. Her work focuses on identity, explored through participatory creative practices.

—

rehabeldalil.com | @rehabeldalil

MARK THIESSEN

LARBI LOUAFI

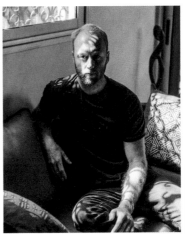
SCHÉHÉRAZADE BOUABID

ETINOSA YVONNE
NIGERIA

—

Etinosa Yvonne is a documentary photographer and visual artist. The focus of her work is the exploration of themes related to the human condition and social justice.

—

etinosayvonne.me | @etinosa.yvonne

ZOHRA BENSEMRA
ALGERIA

—

Zohra Bensemra is the Reuters Chief Photographer for West and Central Africa. She is currently based in Senegal.

—

@zohrabensemra

JOHN WESSELS
SOUTH AFRICA

—

John Wessels is the chief photographer in West Africa for Agence France-Presse. He is currently based in Dakar, Senegal.

—

@johngingerwessels

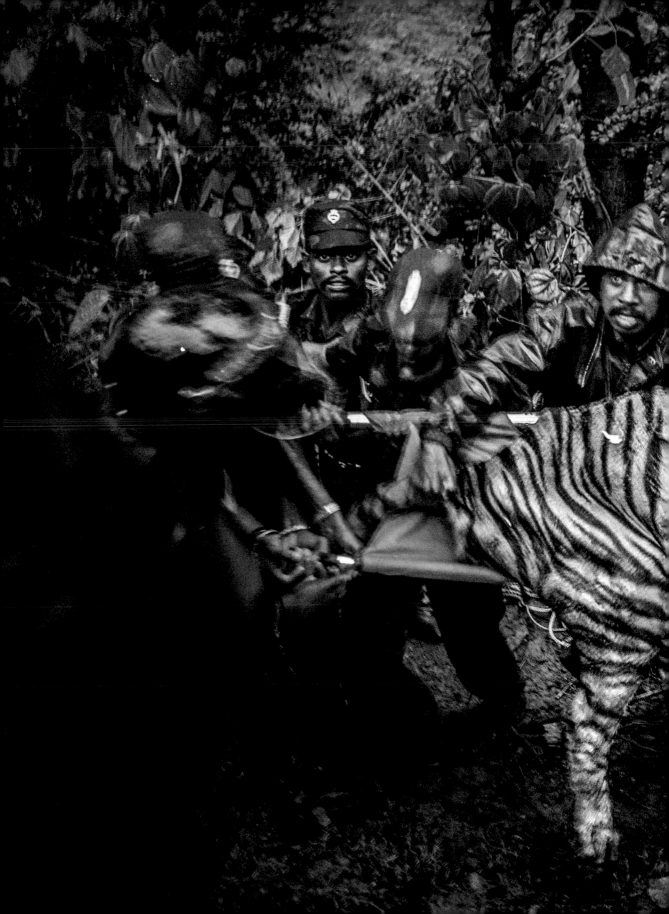

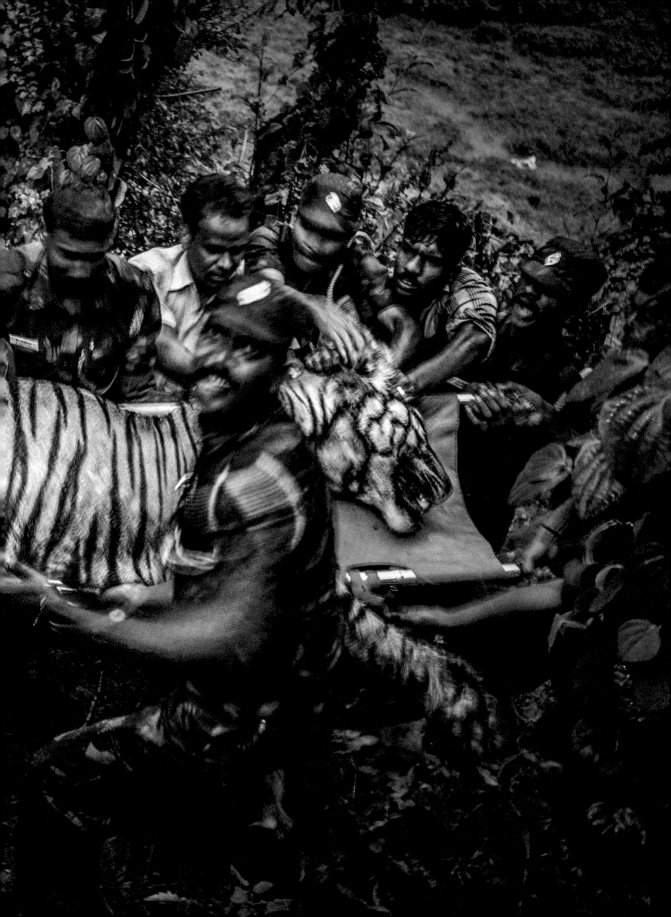

–
Asia
–

Tanzim Wahab
Chair of the Jury for Asia

The new regional focus of the World Press Photo Contest encouraged the regional jury for Asia to be self-reflective, to listen actively, and to ask the most essential questions: Why is it imperative to put power in the hands of communities whose story is being told, and to be mindful of who is telling them? How does journalism reinforce the reproduction of stereotypes instead of combating them in the best interests of the people? How are the boundaries between traditional photojournalism and experimental storytelling shifting, and what effects could this potentially have on the regional audience?

Like many regions across the world, Asia is, now more than ever, facing a democratic struggle, particularly for press freedom and the safety of journalists. In response to deepening social and political polarization, the jury felt strongly that it is now more important than ever for an international photo contest to stand in solidarity with visual story-tellers and to encourage new solutions and strategies for press photography. The submissions in Asia included powerful works on ongoing conflicts, forced and economic migration, ethnic and gender violence, cultural erasure, the climate crisis, labor and farmer move-ments, food insecurity, the impact of the COVID-19 pandemic on mental health, and widened socio-economic inequalities.

The new regional format attracted a wider range of long-term, investigative and self-funded stories, expressing the personal commitment of local photographers. However, it was important for the jury to remember that regional focus and diversity does not always guarantee informed works that capture the complexity of our world, and that the question of credibility still arises in a time of fake news and disinformation.

The entries in the newly introduced Open Format category pushed the limits of visual storytelling. Some approaches deployed interactive strategies to activate mental processes and provoke curiosity; some works represented the absence of the subjects or moments that purposefully disturb the viewer, without disrupting cohesion; some works embraced metaphorical references to unveil the socio-political codes of the image embedded in complex ways. These approaches take advantage of what this transformative moment offers, and open the door to alternative modes of visual journalism.

Winners

—

ZAINAB SHBAIR

SINGLES

FATIMA SHBAIR
PALESTINE

—

Fatima Shbair is a photojournalist based in Gaza City, Palestine. She is a self-taught photographer who has an interest in documenting people's stories, cultures, and social issues.

—

@fatimashbair

FELIPE DANA

STORIES

BRAM JANSSEN
THE NETHERLANDS

—

Bram Janssen is a visual journalist for The Associated Press, and is currently based in Amsterdam, the Netherlands. His work focuses on humanitarian issues, documenting the impact of conflict, corruption, and international politics on everyday life.

—

bramjanssen.nl | @bram_anna

Jury

—

SALMA ABEDIN PRITHI

TANZIM WAHAB / CHAIR
BANGLADESH

—

Tanzim Wahab is a curator, researcher and lecturer at Pathshala South Asian Media Institute and festival director of Chobi Mela International Festival of Photography.

—

pathshalainstitute.org

ERIK TANNER

SANGSUK SYLVIA KANG
SOUTH KOREA

—

Sangsuk Sylvia Kang is a photographer, journalist and photo editor at *TIME*. She is based in New York City.

—

sangsuk.com | @sangsuk.jpg

BALA

KAPIL DAS

LONG-TERM PROJECTS

SENTHIL KUMARAN
INDIA
—
Senthil Kumaran is a documentary photographer and National Geographic Explorer from Madurai, South India. He has worked on various wildlife and conservation projects, highlighting the issues arising from human-animal conflict.
—
senthilphotographer.com | @senthilphotography

OPEN FORMAT

KOSUKE OKAHARA
JAPAN
—
Kosuke Okahara is a documentary photographer and filmmaker known for his intimate approach. Okahara is represented by Polka Galerie, Paris, and Only Photography, Berlin. He is based in Kyoto, Japan.
—
kosukeokahara.com | @kosukeokahara

MEHDI HASANI

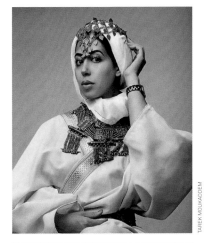
TAREK MOUKADDEM

ATUM IMAGES

ABBAS KOWSARI
IRAN
—
Abbas Kowsari is the senior photo editor for *Shargh Daily* and *Aftab Network Magazine*.
—
abbaskowsari.com | @abbaskowsari

TASNEEM ALSULTAN
SAUDI ARABIA
—
Tasneem Alsultan is an investigative photographer and visual storyteller. Her work documents social issues and rights-based topics in Saudi Arabia and the Arab Gulf region.
—
tasneemalsultan.com | @tasneemalsultan

LAM YIK FEI
HONG KONG
—
Lam Yik Fei is a freelance photographer who focuses on bringing awareness to social, environmental and human-related issues.
—
lamyikfei.com | @lamyikfei

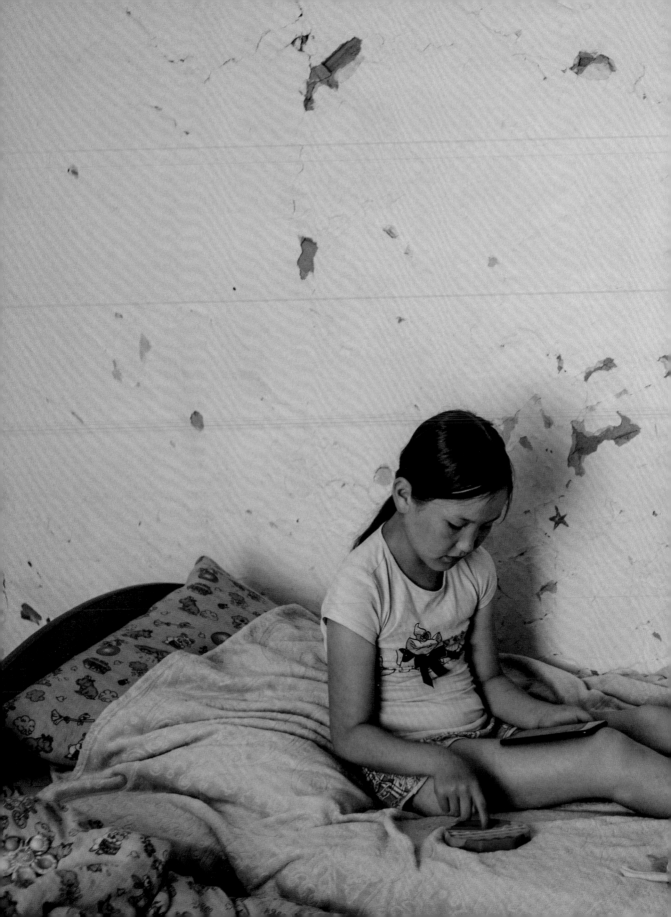

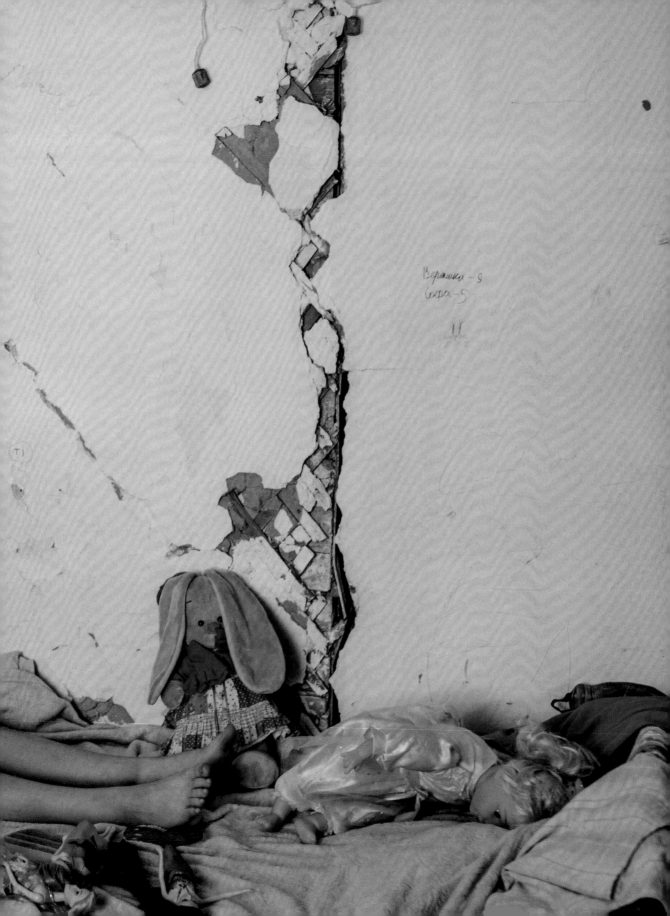

Europe

Simona Ghizzoni
Chair of the Jury for Europe

The regional jury for Europe was looking for visually striking works that drew attention to local issues, but were at the same time relevant from a global perspective. We were looking for common ground and had long discussions about what is relevant within a macro-region like Europe, which encompasses extremely distant countries. The new system of judging gave us a way to delve deeper into the crucial issues in the region, and appreciate the differences in approach among the photographers.

The privilege of being able to look at an extraordinary number of images has given us an overall view of the entire region: Europe seems to be going through deep crises and protests, turmoil, unrest and the winds of war. It has also been living in a state of social isolation for more than two years due to the COVID-19 pandemic, with serious psychological, economic and social consequences.

Stories dealing with the climate crisis particularly affected us, especially the wildfires, which devastated many countries in 2021, including Greece, Italy, Russia and Spain. Floods in Germany and in Bosnia and Herzegovina were among the most documented events.

Finally, the theme of information, propaganda and fake news sparked particular interest in the jury, allowing us to reflect on the very role of photojournalism and the need to continue to ensure information is as accurate and independent as possible.

The jury particularly appreciated those works in which a genuine involvement on the part of the photographer was evident, and those that reflected human emotion as a stimulus for empathy. "We look for proximity, for closeness to the subject," was one of the statements most shared among the jurors.

Within this great fresco, we also tried to identify smaller, more intimate stories that could shed new light on universal themes and generate greater awareness of our complex contemporary world.

Winners

—

ANGELOS ZYMARAS

VLAD MOLODEEZ

SINGLES

KONSTANTINOS TSAKALIDIS
GREECE
—
Konstantinos Tsakalidis is a freelance photojournalist based in Thessaloniki, Greece. Tsakalidis is a contributor for Bloomberg News covering social and political issues in Greece, Eastern Europe and Turkey.
—
@tsakalidis_k

STORIES

NANNA HEITMANN
GERMANY/RUSSIA
—
Nanna Heitmann is a documentary photographer based in Moscow, Russia. Her work deals with issues of isolation, as well as the nature of how people interact with their environments.
—
nannaheitmann.com | @nannaheitmann

Jury

—

SIMONA GHIZZONI

GURAM MUIRADOV

SIMONA GHIZZONI / CHAIR
ITALY
—
Simona Ghizzoni is a photographer, visual artist and activist for women's rights. She is the co-founder of MAPS Images and is represented by MLB Gallery.
—
simonaghizzoni.com | @simona.ghizzoni

NESTAN NIJARADZE
GEORGIA
—
Nestan Nijaradze is the artistic director and co-founder of the Tbilisi Photo Festival and the Tbilisi Photography and Multimedia Museum.
—
@nestannijaradze

LONG-TERM PROJECTS

GUILLAUME HERBAUT
FRANCE

–

Guillaume Herbaut is a photographer based in Paris, France. He is a member of Agence VU'. Herbaut photographs historical places filled with memory. His recent work focuses on the conflict in Ukraine.

–

guillaume-herbaut.com | @guillaumeherbaut

OPEN FORMAT

JONAS BENDIKSEN
NORWAY

–

Jonas Bendiksen is a photographer based near Oslo, Norway. He has been a member of Magnum Photos since 2004. Across his body of work, Bendiksen often focuses on people and communities forming isolated enclaves.

–

jonasbendiksen.com | @jonasbendiksen

MADS NISSEN
DENMARK

–

Mads Nissen is a staff photographer at *Politiken* and member of Panos Pictures. He focuses on contemporary social, environmental and human rights issues.

–

madsnissen.com | @madsnissenphoto

ISTVÁN VIRÁGVÖLGYI
HUNGARY

–

István Virágvölgyi is a curator for the Robert Capa Contemporary Photography Center and a volunteer editor of Fortepan Digital Photo Archive.

–

viristvan.com | capacenter.hu

STEPHANIE HARKE
GERMANY

–

Stephanie Harke is a freelance photo editor, photographer and producer whose expertise is in photojournalism and documentary photography.

–

stephanieharke.com | @stephanie_harke

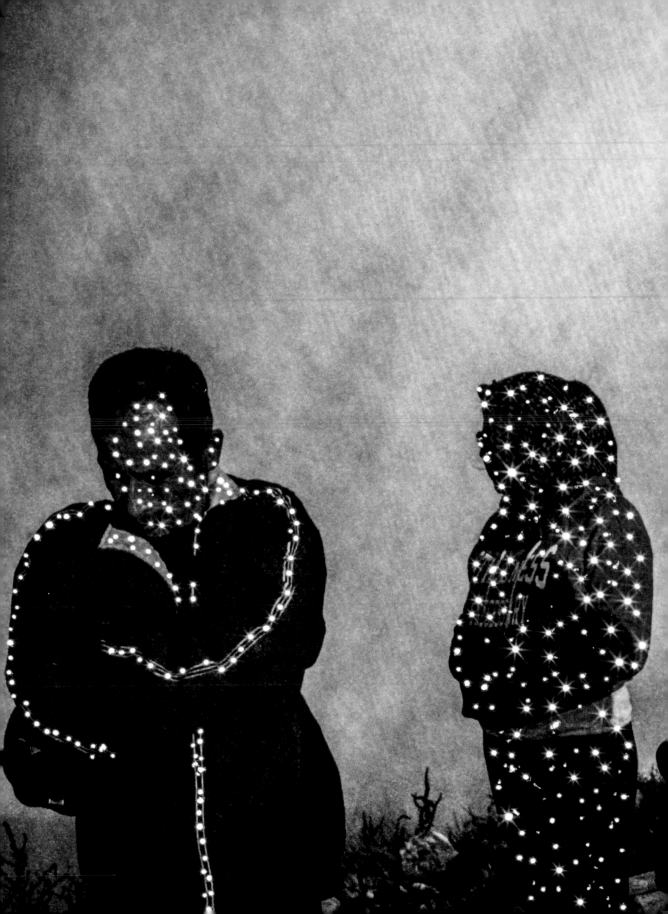

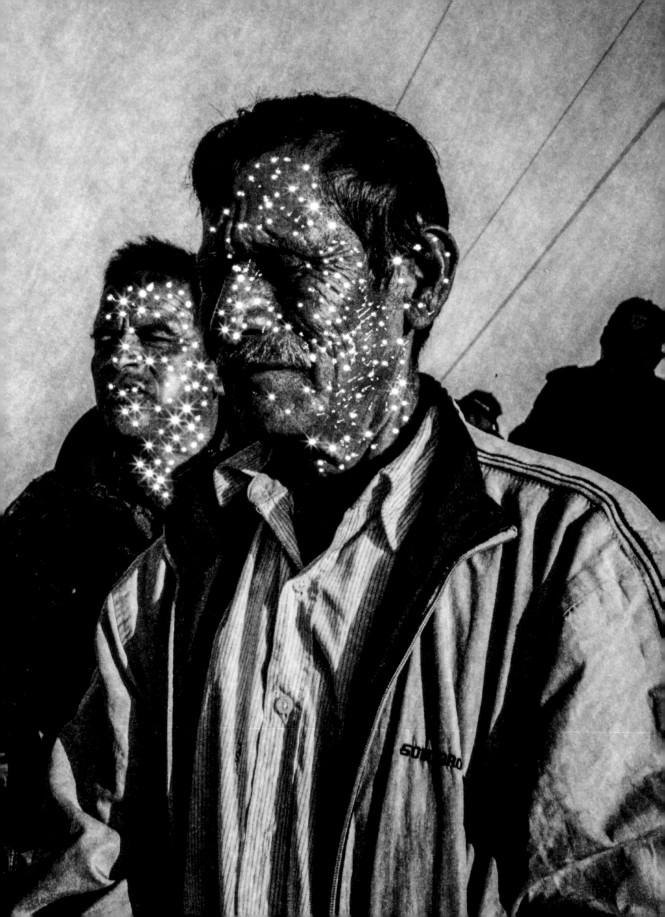

North and Central America

Clare Vander Meersch
Chair of the Jury for North and Central America

Before judging began, we – the jury for North and Central America – shared our vision for an ideal outcome: to strive to include work that would create a theme of diversity and inclusion. We endeavored to give special consideration to stories that put the I in BIPOC; that showed women bearing the economic brunt of the pandemic; that showcased the push for fair treatment for LGBTQI+ communities; and that portrayed people with disability – all while making sure we still touched upon the biggest news stories of the year. Ultimately, our hope was to give more space to better reflect the world we want to live in.

We saw many entries on human migration. This evoked impassioned discussion, and a wider desire to minimize the impact of a one-dimensional viewpoint. We saw a tendency to view migrant experiences as a monolith, showing a mass of people rather than taking a deeper look at individuals. There is a historical problem of outsiders not fully grasping the regional distinctions of a range of cultural experiences, of covering high-impact events rather than looking into why this was happening.

We were also concerned that many entries perpetuated a one-sided narrative portraying Central America as a sad and violent place – one

which people had no choice but to leave. We were looking for nuanced stories beyond this worn-out narrative.

The jury expressed a similar sentiment about Indigenous representation. The caliber of entries covering stories about those communities was impressively high, but we saw that many of these entries were still told by outsiders.

We debated at length how we are trying to break with visual journalism of the past, and how the future might differ. And how despite the restructuring of the contest, it may take years for this to trickle down into the photo community itself, so that the range of entries becomes more diverse. There is much still to be done to make deeper connections with the photo community and uplift more work.

So the questions become: How will World Press get involved with communities to be more proactive in getting their entries? How do we encourage those with resource and access challenges and entice more people to pick up a camera to document locally important stories?

Winners

—

JASON FRANSON

DANIELLE AMY

SINGLES

AMBER BRACKEN
CANADA
—
Amber Bracken is a freelance photo-journalist based in Edmonton, Canada. Her work explores intersections of race, environment, culture and decolonization, specializing in relationship-based and historically contextualized storytelling.
—
amberbracken.com | @photobracken

STORIES

ISMAIL FERDOUS
BANGLADESH
—
Ismail Ferdous is a photographer and filmmaker based in New York, United States. His work documents social and humanitarian issues of the contemporary world. He is a member of Agence VU'.
—
iferdous.com | @ismailferdous

Jury

—

LUIS MORA

JASMINE LEWIS

CLARE VANDER MEERSCH / CHAIR
CANADA
—
Clare Vander Meersch is the director of photography of *Report on Business* magazine and a photo editor of the Visuals team of *The Globe and Mail*.
—
@photo_editor_clare

BRENT LEWIS
UNITED STATES
—
Brent Lewis is a photo editor at *The New York Times* and the co-founder of Diversify Photo.
—
blewisphoto.com | @blewisphoto

CHLOE COLEMAN

LUCERO GRANDA

LONG-TERM PROJECTS

LOUIE PALU
CANADA
–

Louie Palu is a photographer and film-
maker whose work examines social-
political issues, such as human rights
and conflict. He is currently based in
Washington DC, United States.
–
louiepalu.com | @louiepalu

OPEN FORMAT

YAEL MARTÍNEZ
MEXICO
–

Yael Martínez is a photographer based
in Taxco, Mexico. His work, which often
evokes a sense of emptiness, absence,
and pain, addresses fractured commu-
nities in his homeland. He is a member
of Magnum Photos.
–
yaelmartinez.com | @yaelmtzv

JOSUÉ RIVAS

PATRICK MACLEOD

VERÓNICA SANCHIS BENCOMO

JOSUÉ RIVAS
MEXICO
–

Josué Rivas is an Indigenous futurist,
creative director, visual storyteller and
educator. His work aims to challenge
the mainstream narrative about Indig-
enous peoples and co-create with the
community.
–
josuerivas.co | @josue_foto

TOMAS AYUSO
HONDURAS
–

Tomas Ayuso is a writer and documen-
tary photojournalist. His work focuses
on Latin American conflict in relation
to the drug war, forced displacement
and urban dispossession.
–
tomasayuso.com | @tomas_ayuso

VERÓNICA SANCHIS BENCOMO
SPAIN/VENEZUELA
–

Verónica Sanchis Bencomo is a
photographer and curator based in
New York. Her mission is to celebrate
and archive the work of female Latin
American photographers.
–
veronicasanchis.com |
@veronicasanchis

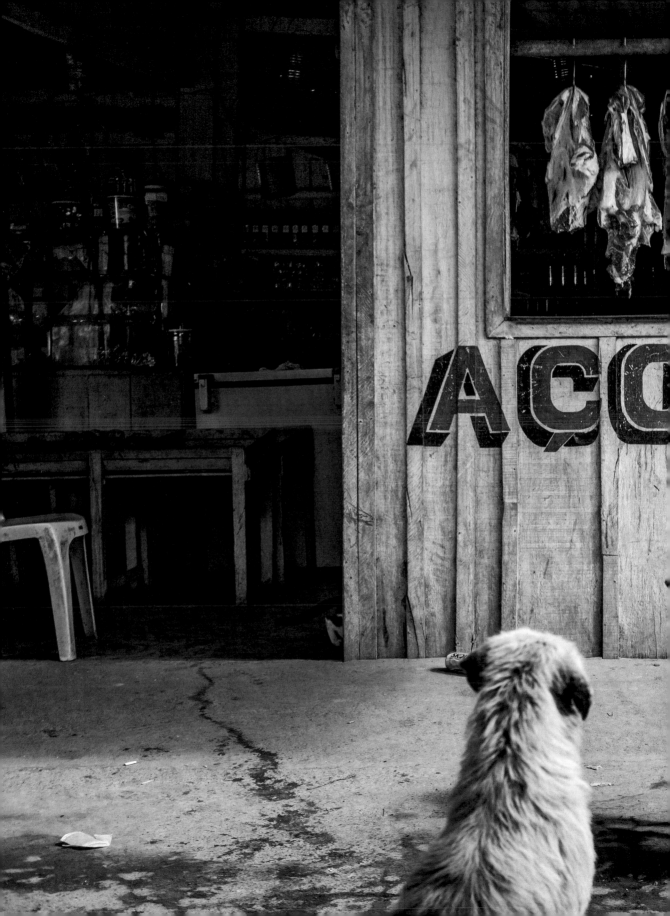

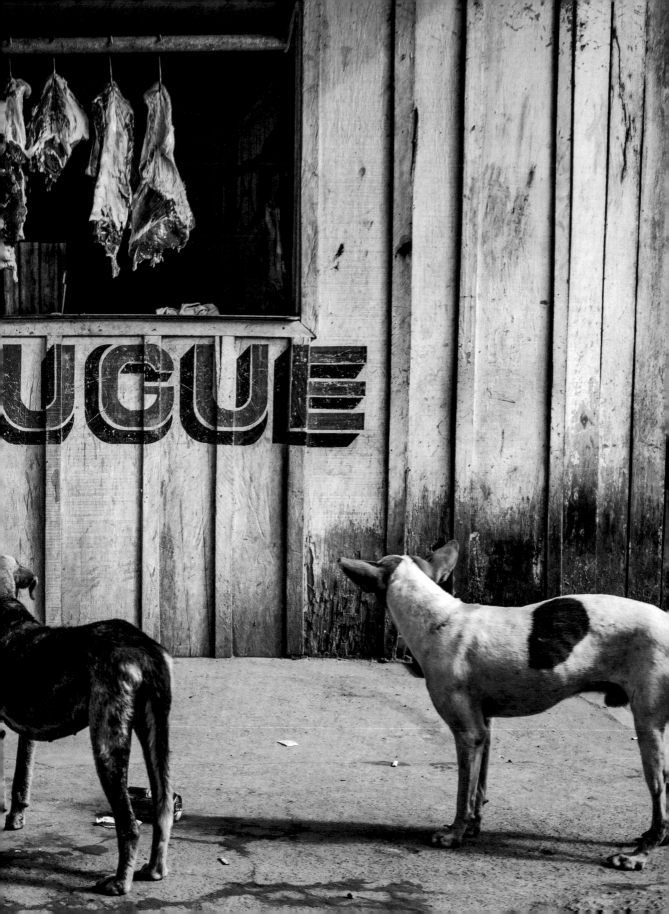

–
South
America
–

Ernesto Benavides
Chair of the Jury for South America

As members of the South American jury, we found ourselves constantly discussing and trying to find an answer to the question: What is being represented in these photographs, and what kind of conventional stigmas and global reporting trends are being reaffirmed instead of being questioned? It is a question that always left us wishing we had more time to attempt an answer. Allowing space to have such discussions is important and stretches beyond the context of the World Press Photo awards.

Photographers in the region submitted a wide variety of projects, of good photographic quality and covering a range of social, political, cultural, environmental, and personal stories. The Long-Term Projects and Open Format categories contained stimulating, thoroughly researched, and serious work.

Projects in which the time spent has meant a great aesthetic development and an important connection between the photographer and the story stood out. Entries from this region showed us the crossing of difficult terrain, from the jungle to the arid desert, from Chile to Venezuela, with the migration of Haitian and Venezuelan citizens; environmental

crises in Brazil, showing the devastation of the Amazon from various angles, as in the case of the *Amazonian Dystopia* project; as well as Indigenous communities and the loss of their land, threats to human rights, political instability in Colombia and old wounds that still bleed in Peru.

We saw stories focused on mineral extraction in Chilean and Bolivian deserts; LGBTQI+ communities; and sensitive stories of small communities and families in more remote parts of the continent, where local traditions or aspects of family life lent themselves to poetic, gentle, and positive representations. Stories such as *The Promise* tell us how the COVID-19 pandemic and its consequences still plague the region by highlighting the precariousness of health and education systems in many South American countries from a unique and empowering angle, instead of pointing out this problem from a perspective of pain and suffering, which is how we have been witnessing it in recent years.

The process of selecting the winners was intense but enriching. It was a privilege to see what photographers are choosing to document and how they are approaching these stories.

Winners

—

MANITOGRAFO

IRINA WERNING

SINGLES

VLADIMIR ENCINA
COLOMBIA

—

Vladimir Encina is a photographer based in Pereira, Colombia. Encina works within small, local communities to highlight the struggles of everyday life that stem from the large social inequality in his region.

—

@manitografo

STORIES

IRINA WERNING
ARGENTINA

—

Irina Werning is a freelance photo-journalist who focuses on personal long-term projects. She is based in Buenos Aires, Argentina.

—

irinawerning.com | @irinawerning

Jury

—

GIHAN TUBBEH

STEFANO POZZEBON

ERNESTO BENAVIDES / CHAIR
PERU
—

Ernesto Benavides is a photographer for Agence France-Presse, working primarily within South America.

—

ernestobenavidesphoto.com | @ernestobenavidesde

FABIOLA FERRERO
VENEZUELA

—

Fabiola Ferrero is a journalist and photographer whose work documents the emotional side of Venezuela's crisis and focuses on the human condition. She is currently based between Venezuela and Colombia.

—

fabiolaferrero.com | @FabiolaFerrero

EDUARDO KNAPP

ANA MARÍA BUITRÓN

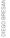

LONG-TERM PROJECTS

LALO DE ALMEIDA
BRAZIL
–

Lalo de Almeida is a photographer based in São Paulo, Brazil. He works for *Folha de São Paulo* and has been represented by Panos Pictures since 2020.
–
lalodealmeida.com.br | @lalodealmeida

OPEN FORMAT

ISADORA ROMERO
ECUADOR
–

Isadora Romero is a freelance visual storyteller based in Quito, Ecuador. Her work focuses on social, gender, and environmental issues. Romero is the co-founder of Ruda Colectiva.
–
isadoraromero.com | @isadoraromerophoto

PEDRO VILLEGAS

HERMANN STEFFEN

DIEGO BRESANI

GEOVANNY VILLEGAS SÁNCHEZ
ECUADOR
–

Geovanny 'Gato' Villegas Sánchez is a cultural and audiovisual producer. He is interested in the dialogue between art and documentary as a way to renew its narrative.
–
gatovillegas.com | @gato_villegas

VERONICA CORDEIRO
BRAZIL
–

Veronica Cordeiro is an independent artist, curator and writer based in Montevideo, Uruguay.
–
@tierra_art_platform | @poetics_of_transmutation

DENISE CAMARGO
BRAZIL
–

Denise Camargo is a visual artist, curator and professor in the Department of Visual Arts at the Federal University of Brasília.
–
@camargodenise

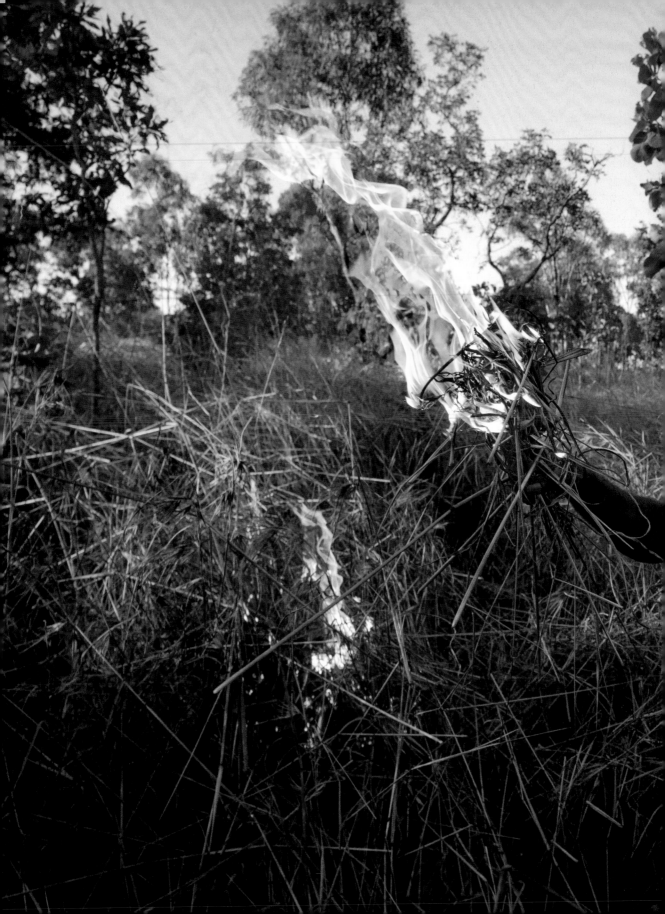

Southeast Asia and Oceania

Jessica Lim
Chair of the Jury for Southeast Asia and Oceania

In a line of work that requires much of your heart and hope, I am constantly buoyed and inspired by peers who find ways to persist in their commitment to journalism. As the first regional jury for Southeast Asia and Oceania gathered virtually to begin our deliberations, we found ourselves coming across instance upon instance of tireless dedication by professionals from our part of the world.

In the third year of the COVID-19 pandemic, visual journalists from our region continued their documentation of the virus' impact on individual lives and local communities. From private grief in homes to collective anger on the streets, these stories were brought to us by photographers at risk of their own health and lives.

While we have vaccines and protective gear to reduce the risk of COVID-19, there is little to be done in the face of tear gas, rubber bullets and live ammunition. In Myanmar, photographers recorded the heartbreak of a nation after a military coup destroyed years of democratic progress overnight, resulting in protests, armed resistance, violent arrests and killings of civilians. Across the border in Thailand, we saw scenes of people resisting curtailment of their civil liberties, taking to the streets to continue their call for reforms to

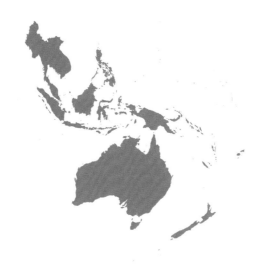

the monarchy and constitution. Both events are just the latest in a continuing pattern in the ongoing resurgence of authoritarianism in Southeast Asia.

The region's visual journalists continued to document the multiple facets of climate change and mankind's tumultuous relationship with the environment, whether that required wading through flood water or facing a fast-approaching wall of fire. While these events dominated headlines, we received many other stories that need to be shared – from the wisdom of ancient cultures to heartfelt personal work and beautiful wildlife.

Last but not least, in this age of visual saturation, it is also important for us to think about the images we don't see – where are the gaps and silences, and why? The obstacles are many – from a lack of funding to the curtailment of press freedom and threats of violence – and are reminders of how important it is for organizations like World Press Photo to continue recognizing and advocating for the contributions made by visual journalists.

Winners

—

SINGLES

ANONYMOUS

—

The photographer remains anonymous for reasons of personal safety.

MATTHEW ABBOTT

STORIES

MATTHEW ABBOTT
AUSTRALIA

—

Matthew Abbott is a documentary photographer based in Sydney. He photographs social, cultural and political stories covering contemporary suburban and regional Australia.

—

matthewabbott.com.au | @mattabbottphoto

Jury

—

JESSICA LIM

JESSICA LIM / CHAIR
SINGAPORE

—

Jessica Lim is the director of Angkor Photo Festival and Workshops (APFW). Throughout her career she has worked towards supporting visual storytellers from the majority world.

—

@elsija

EZRA ACAYAN

EZRA ACAYAN
PHILIPPINES

—

Ezra Acayan is a photojournalist whose work covers politics, climate change and social justice.

—

@ezra_acayan

ABRIANSYAH LIBERTO

PENELOPE RUSSAK

LONG-TERM PROJECTS

ABRIANSYAH LIBERTO
INDONESIA

–

Abriansyah Liberto is a photographer
and photojournalist from Palembang,
South Sumatra, Indonesia. His works
focus on social and environmental
issues.

–

@abriansyah_liberto

OPEN FORMAT

CHARINTHORN RACHURUTCHATA
THAILAND

–

Charinthorn Rachurutchata is a photog-
raphy-based visual artist who is inter-
ested in gender inequality, religious,
social and political issues. She is based
in Bangkok, Thailand.

–

@charinthorn_rachurutchata

LE XUAN PHONG

JAMES BRICKWOOD

UTAMI GOZALI

LINH PHAM
VIETNAM

–

Linh Pham is a photographer who
explores the human condition in the
Lower Mekong region. He is the
co-founder of Matca, a leading
platform for photography in Vietnam.

–

linh-pham.com | @phamhaduylinh

MAGS KING
UNITED KINGDOM

–

Mags King is the managing photo editor
at *The Sydney Morning Herald*. A photo
editor for over 20 years, she is also a
curator, producer, speaker and mentor.

–

@mags__king.

YOPPY PIETER
INDONESIA

–

Yoppy Pieter is a photographer and
educator who focuses on telling a
diverse range of stories that explore
identity, religion and social culture.

–

yoppy-pieter.com | @yoppy.pieter

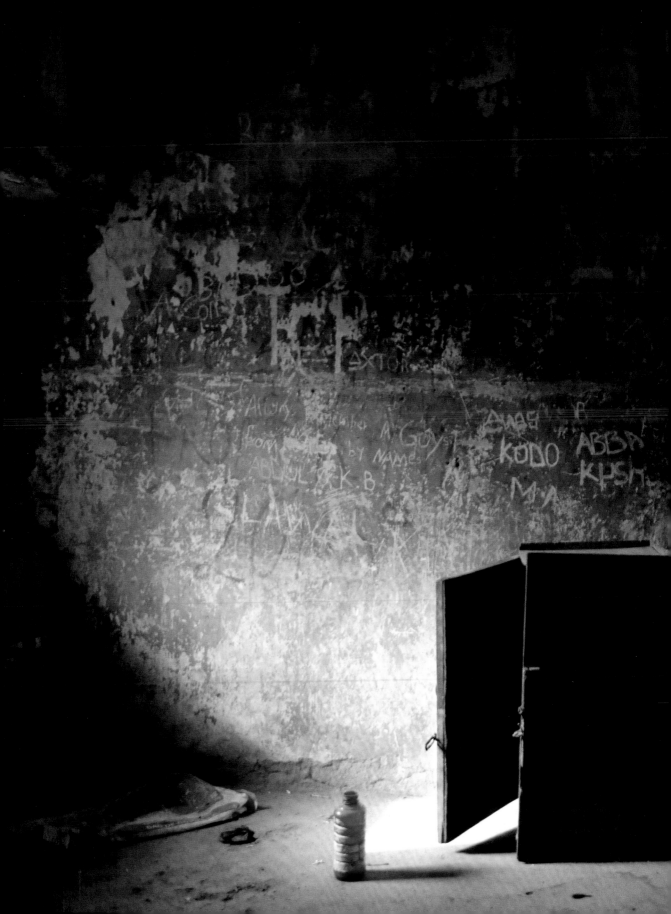

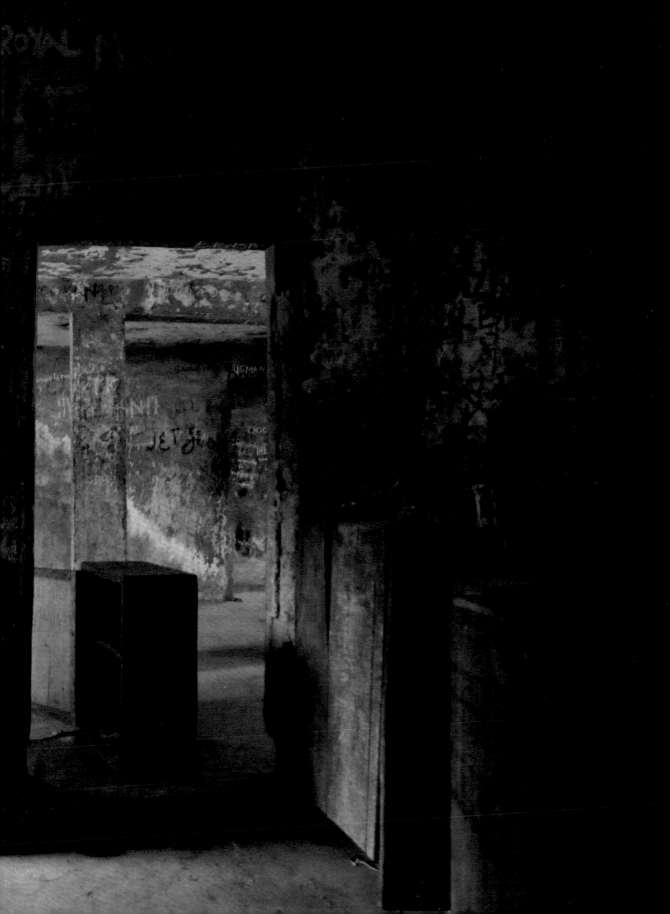

Global Jury

—

Rena Effendi
Chair of the Global Jury

I am honored and proud to have been part of this exciting new chapter in the history of the World Press Photo Contest. The new regional format with fewer categories pushed us out of our comfort zone, and gave us an imperative to look for stories that provided a more nuanced vantage point on issues the world has been grappling with in the past year.

The majority of the winners this year are based in the same countries where the photographs were taken. It was not a deliberate decision on the part of the jury to exclude the work of outsiders. In the process of judging, it occurred to us that some of the more compelling stories were told from a personal angle by those present on the ground and deeply committed to the subject. Many of these photographers were intimately connected to the communities whose lives they portrayed in a way that was both sensitive and responsible. As a jury, we naturally gravitated towards projects that challenged conventional stereotypes, rather than reinforced them.

Some themes were overarching across the various regions of the globe. The stories and photographs of the global winners, for example, are interconnected. All four of them, in their own unique ways, address the consequences of humanity's rush for progress, and its devastating effects on our planet. These projects not only reflect upon the immediate urgency of the climate crisis, but also give us an insight into possible solutions.

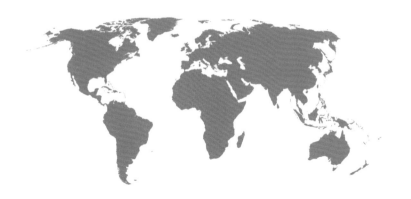

The Open Format Award winner *Blood is a Seed* addresses the consequences of colonization, eradication of culture and loss of heritage, while reclaiming traditional agricultural practices in an act of resistance.

The Long-Term Project *Amazonian Dystopia* unveils a multitude of disastrous results of the exploitation of land and natural resources – the impact of short-sighted decisions driven by greed and enforced by those in power without any regard for the planet's future.

In contrast to *Amazonian Dystopia*, the winning World Press Photo Story of the Year on the Aboriginal practice of controlled burning of land in Australia gives us a rare glimpse of a possible solution to our rapidly heating world, which resonated deeply with the jury.

And finally, the World Press Photo of the Year, depicting dresses hanging over the recently discovered unmarked graves of the First Nations children in Canada, is a quiet moment of global reckoning for the history of colonization, not only in Canada but around the world.

Together the global winners pay tribute to the past, while inhabiting the present and looking toward the future.

Winners

—

AMBER BRACKEN
PHOTO OF THE YEAR

MATTHEW ABBOTT
STORY OF THE YEAR

LALO DE ALMEIDA
LONG-TERM PROJECT AWARD

ISADORA ROMERO
OPEN FORMAT AWARD

Global
Jury
—

Rena Effendi is a documentary photographer who focuses on issues of conflict, social justice and the environment. She is currently based in Istanbul, Turkey.
—
refendi.com | @renaeffendiphoto

MARIA KLENNER

RENA EFFENDI / CHAIR
AZERBAIJAN

N'GONÉ FALL
CHAIR / AFRICA

TANZIM WAHAB
CHAIR / ASIA

SIMONA GHIZZONI
CHAIR / EUROPE

CLARE VANDER MEERSCH
CHAIR / NORTH AND CENTRAL AMERICA

ERNESTO BENAVIDES
CHAIR / SOUTH AMERICA

JESSICA LIM
CHAIR / SOUTHEAST ASIA AND OCEANIA

Honorable mentions

—

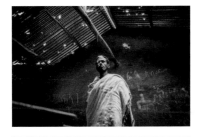

AFRICA
SEARCHING FOR PEACE
AMIDST CHAOS

—

Amanuel Sileshi, Agence France-Presse
Ethiopia

—

@amanuel4sileshi

ASIA
ENDLESS WAR

—

Dar Yasin, for The Associated Press
India

—

@daryasinap

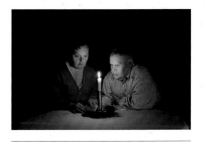

EUROPE
M+T

—

Mary Gelman
Russia

—

marygelman.com | @marygelman

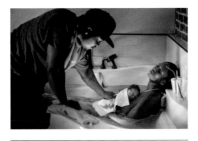

NORTH AND CENTRAL AMERICA
AMID HIGH MORTALITY RATES,
BLACK WOMEN TURN TO MIDWIVES

—

Sarah Reingewirtz, for *Los Angeles
Daily News* and Southern California
News Group
United States

—

sarahreingewirtz.com

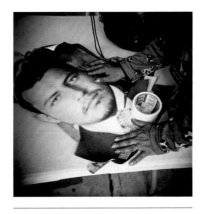

SOUTH AMERICA
A PORTRAIT OF ABSENCE

—

Viviana Peretti
Italy

—

vivianaperetti.com | @vivianaperetti

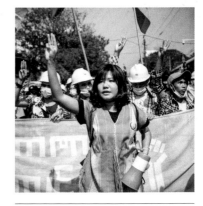

SOUTHEAST ASIA AND OCEANIA
UPRISING IN MYANMAR

—

Ta Mwe, Sacca Photo
Myanmar

—

saccaphoto.com | @tamwephoto

Editor-in-Chief
Joumana El Zein Khoury

Editor
Rodney Bolt

Assistant Editors
Andrew Davies
Daisy Corbin O'Grady
Kuljit Dhami
Mercedes Almagro Ocaña

Production Coordinator
Daisy Corbin O'Grady

Text Coordinator
Mercedes Almagro Ocaña

Image Coordinator
Thera Vermeij

Research Coordinator
Catharine Isabelle
Haitzmann

Research
Francisca Sofia
Corvalan Rojas
Kuljit Dhami
Mark Sheridan
Naomi Purswani
Ryan P.R. Pears
Yatou Sallah

Advisor
Rena Effendi

Design
–SYB–
syb-photobooks.com

Cover
Amber Bracken, for
The New York Times
Kamloops
Residential School

**World Press Photo
Foundation**
World Press Photo,
founded in 1955, is an
independent, non-profit
organization based
in Amsterdam, the
Netherlands.

#WPPh2022

Patron
HRH Prince Constantijn
of the Netherlands

Executive Director
Joumana El Zein Khoury

Supervisory Board
Chair
Janne Nijman
Treasurer
Marlou Banning
Dirk-Jan Visser
Jamila Aanzi
Jolanda Holwerda
Lara Luten

**International
Advisory Committee**
Chair
Brigitte Baptiste
Mark Sealy
Newsha Tavakolian
Tanvi Mishra

Strategic Partners
Dutch Postcode Lottery
PwC

Partners
De L'Europe
Rutgers & Posch

Supporters
The World Press Photo
Foundation appreciates
the support of all its
partners, funders, and
individual donors.

Official Suppliers
Emakina
Eyes on Media &
Eyes on PhotoArt
VCK Logistics

The World Press Photo
Foundation holds 'The
Netherlands Fundraising
Regulator (CBF) Recognition
for Charitable Organiza-
tions', meeting industry
standards for professional,
trustworthy, and trans-
parent practices.

PEFC Certified
This product is from
sustainably managed
forests and controlled
sources
PEFC
10-31-1800 www.pefc.org

Africa

Algeria	Liberia
Angola	**Libya**
Benin	Madagascar
Botswana	**Malawi**
British Indian	Mali
Ocean Territory	**Mauritania**
Burkina Faso	Mauritius
Burundi	**Mayotte**
Cabo Verde	Morocco
Cameroon	**Mozambique**
Central African	Namibia
Republic	**Niger**
Chad	Nigeria
Comoros	**Rwanda**
Congo	Réunion
Côte d'Ivoire	**Saint Helena**
Democratic	Senegal
Republic of the	**Seychelles**
Congo	Sierra Leone
Djibouti	**Somalia**
Egypt	South Africa
Equatorial Guinea	**South Sudan**
Eritrea	Sudan
Eswatini	**São Tomé**
Ethiopia	**and Príncipe**
French Southern	Togo
Territories	**Tunisia**
Gabon	Uganda
Gambia	**United Republic of**
Ghana	**Tanzania**
Guinea	Western Sahara
Guinea-Bissau	**Zambia**
Kenya	Zimbabwe
Lesotho	

Asia

Afghanistan	Macao (China SAR)
Bahrain	**Maldives**
Bangladesh	Mongolia
Bhutan	**Nepal**
China	Oman
Democratic	**Pakistan**
People's Republic	Qatar
of Korea	**Republic of Korea**
Hong Kong	Saudi Arabia
(China SAR)	**Sri Lanka**
India	State of Palestine
Iran (Islamic	**Syrian Arab**
Republic of)	**Republic**
Iraq	Taiwan
Israel	**Tajikistan**
Japan	Turkmenistan
Jordan	**United Arab**
Kazakhstan	**Emirates**
Kuwait	Uzbekistan
Kyrgyzstan	**Yemen**
Lebanon	

Europe

Åland Islands	Latvia
Albania	**Lichtenstein**
Andorra	Lithuania
Armenia	**Luxembourg**
Austria	Malta
Azerbaijan	**Monaco**
Belarus	Montenegro
Belgium	**Netherlands**
Bosnia and	North Macedonia
Herzegovina	**Norway**
Bulgaria	Poland
Croatia	**Portugal**
Cyprus	Republic of Kosovo
Czechia	**Republic of Moldova**
Denmark	Romania
Estonia	**Russian Federation**
Faroe Islands	San Marino
Finland	**Sark**
France	Serbia
Georgia	**Slovakia**
Germany	Slovenia
Gibraltar	**Spain**
Greece	Svalbard and Jan
Guernsey	Mayen Islands
Holy See	**Sweden**
Hungary	Switzerland
Iceland	**Turkey**
Ireland	Ukraine
Isle of Man	**United Kingdom of**
Italy	**Great Britain and**
Jersey	**Northern Ireland**